How To Draw Animals For Kids

This Drawing Tutorial for Kids belongs to:

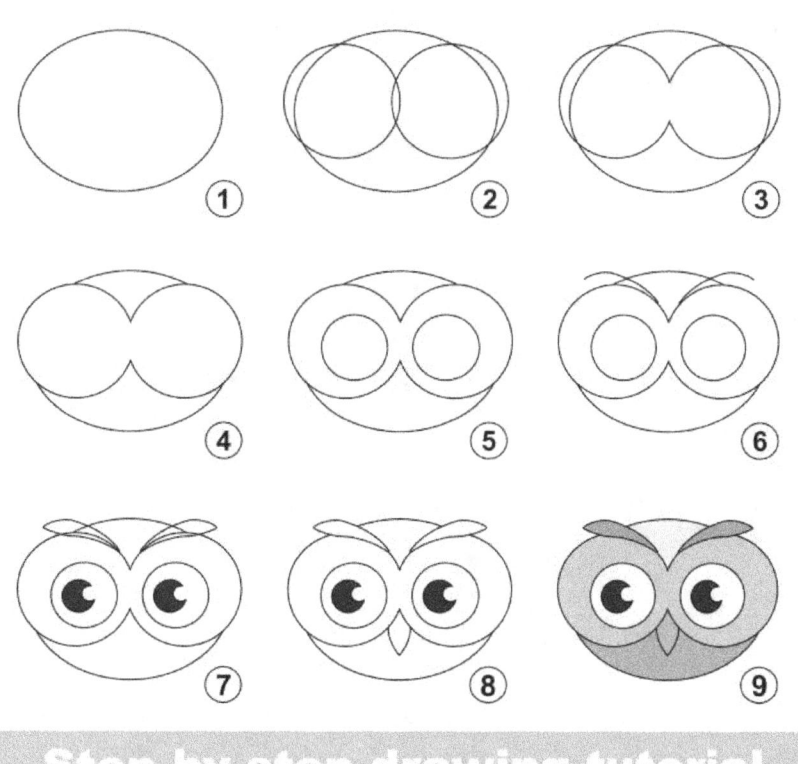

Copyright © 2019 Kids Activity Books

BLANK PRACTICE PAGE

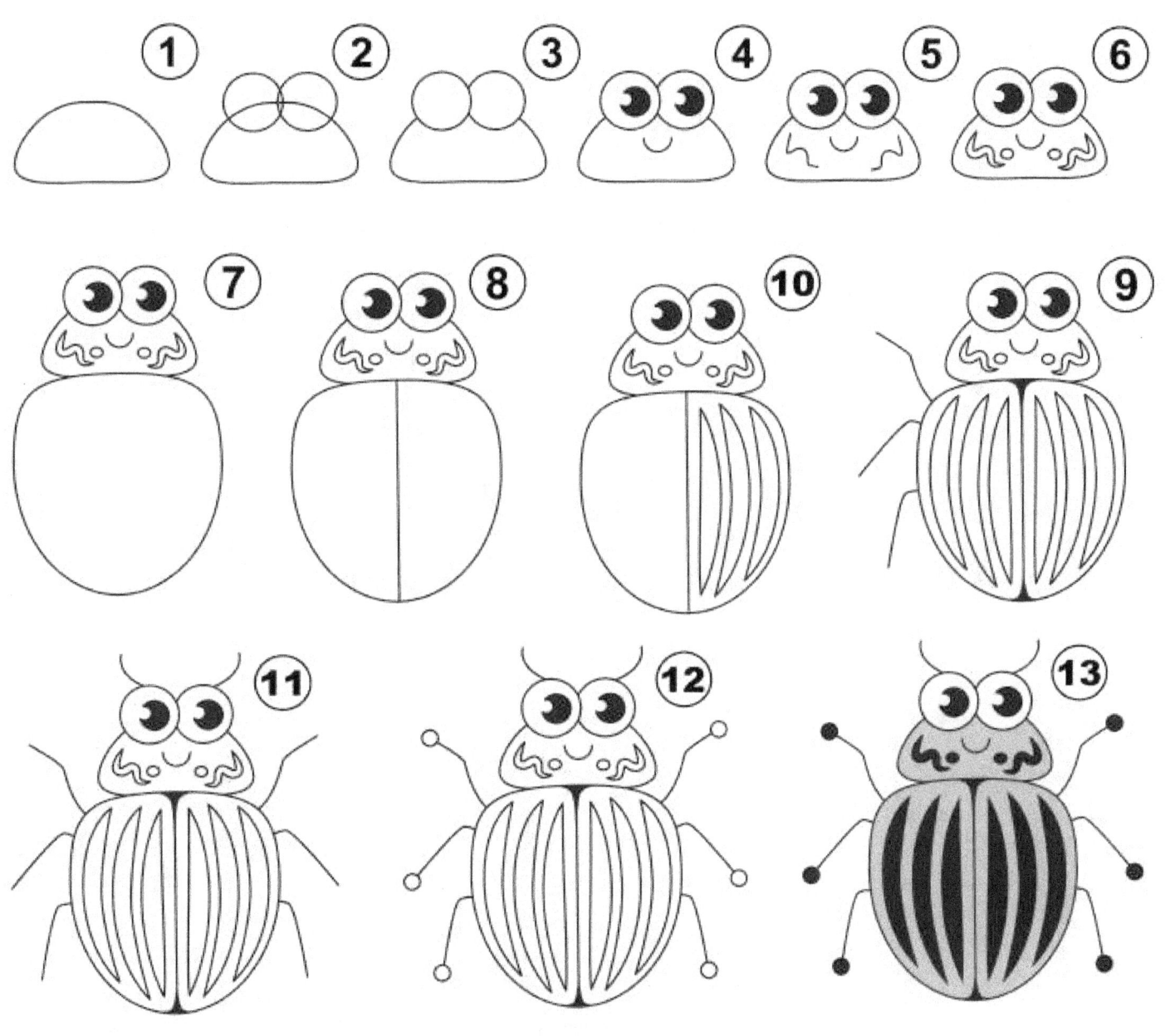

Step by step drawing tutorial

BLANK PRACTICE PAGE

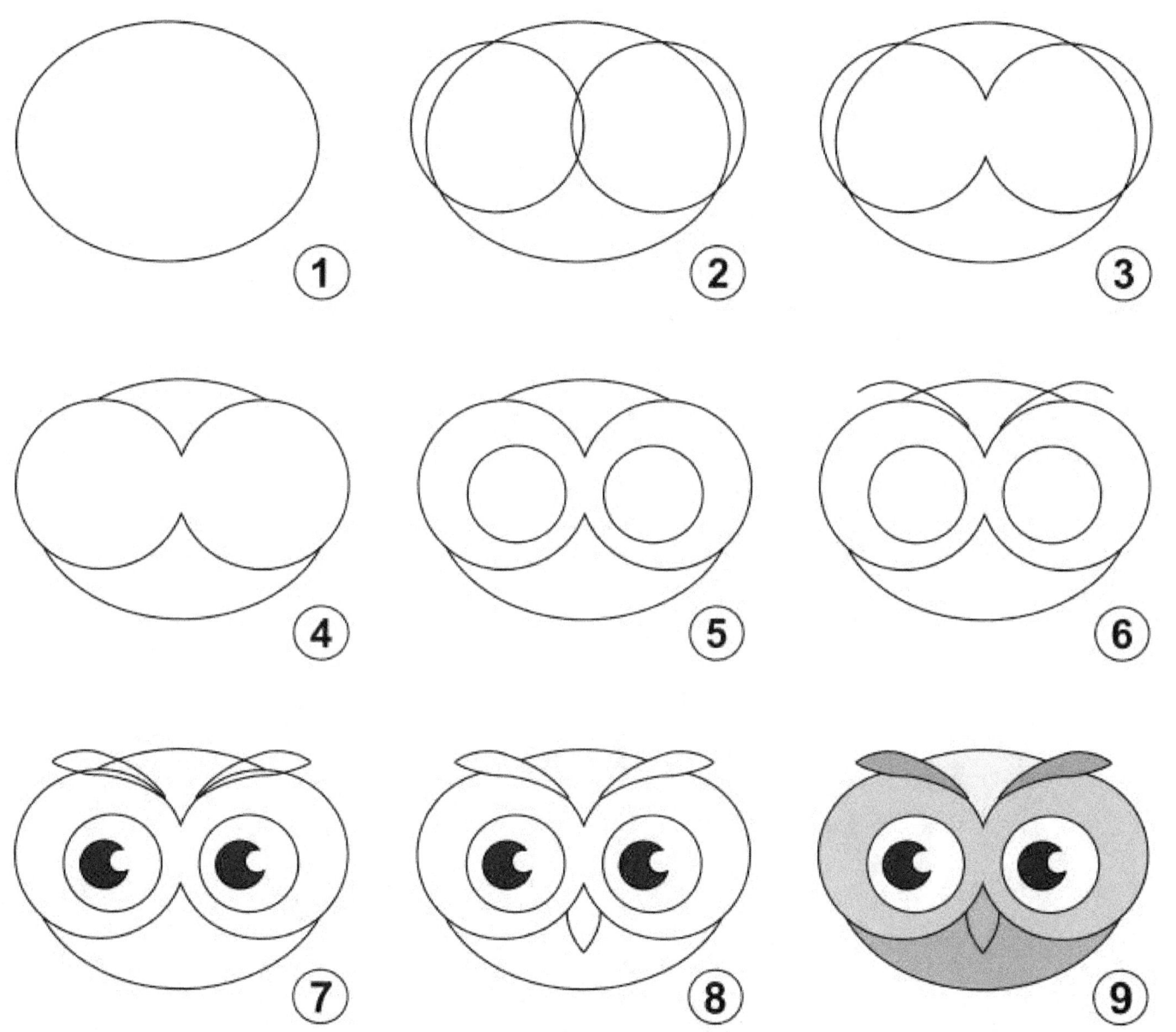

BLANK PRACTICE PAGE

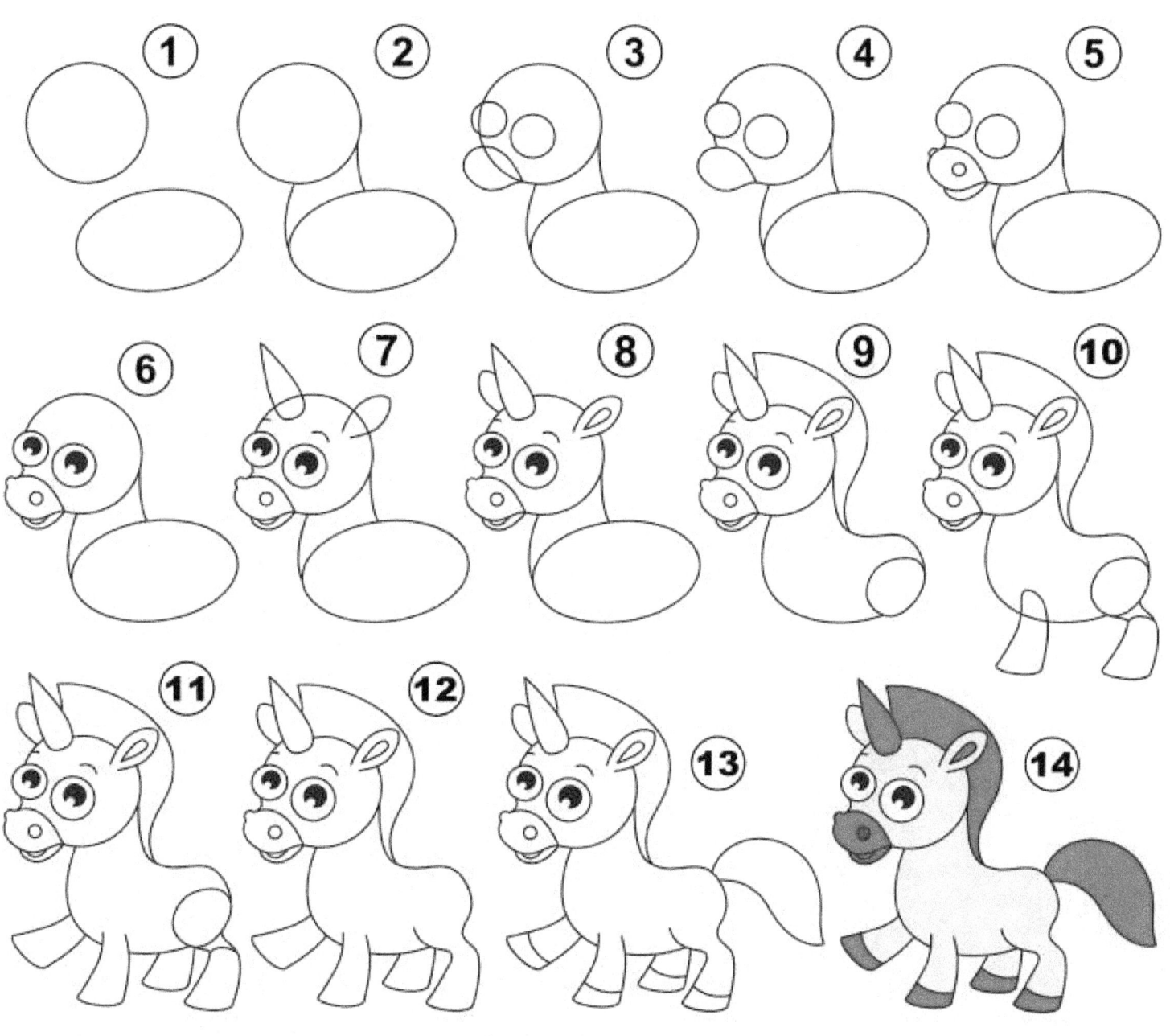

Step by step drawing tutorial

BLANK PRACTICE PAGE

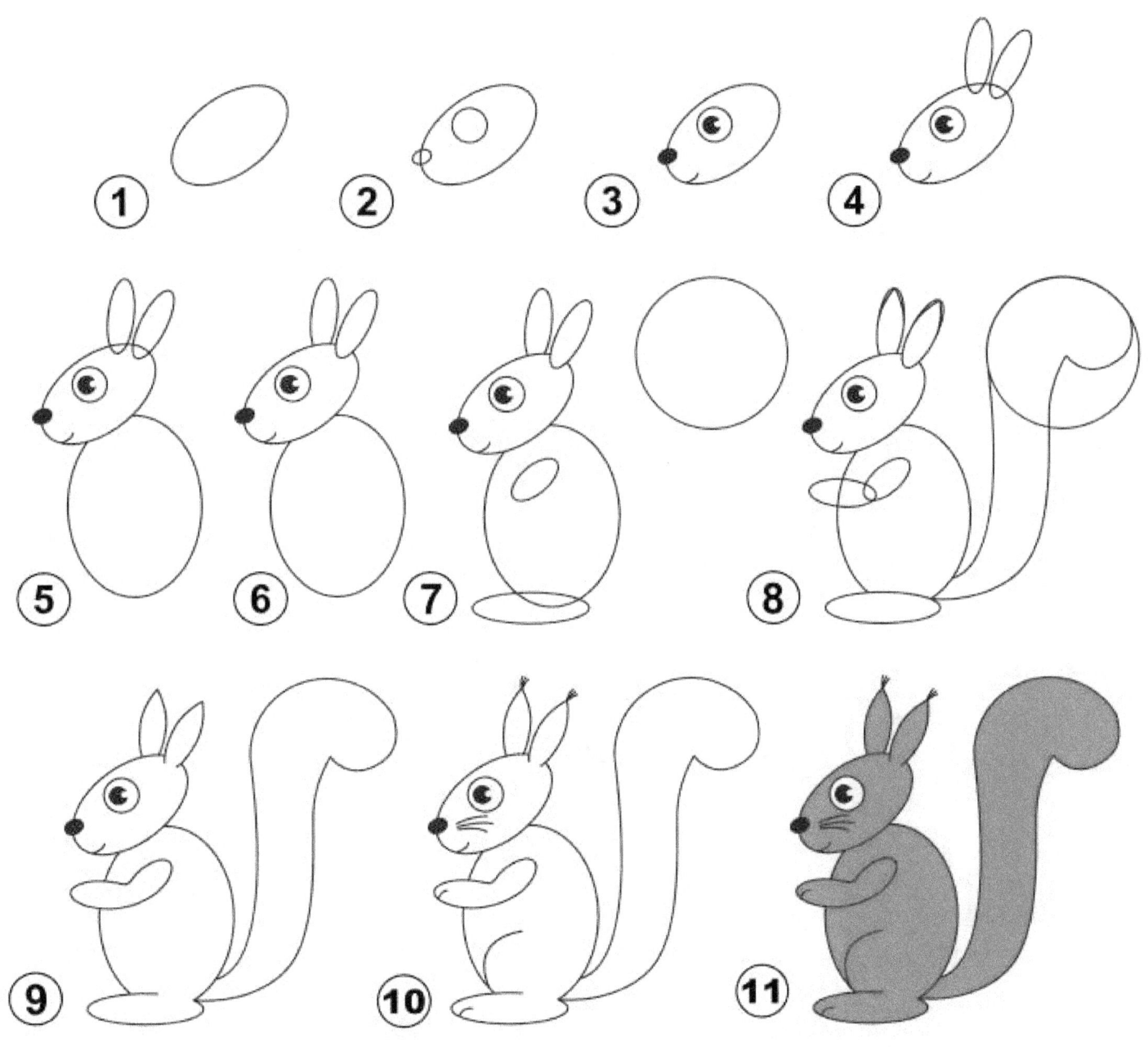

Step by step drawing tutorial

BLANK PRACTICE PAGE

HOW TO DRAW A CAT

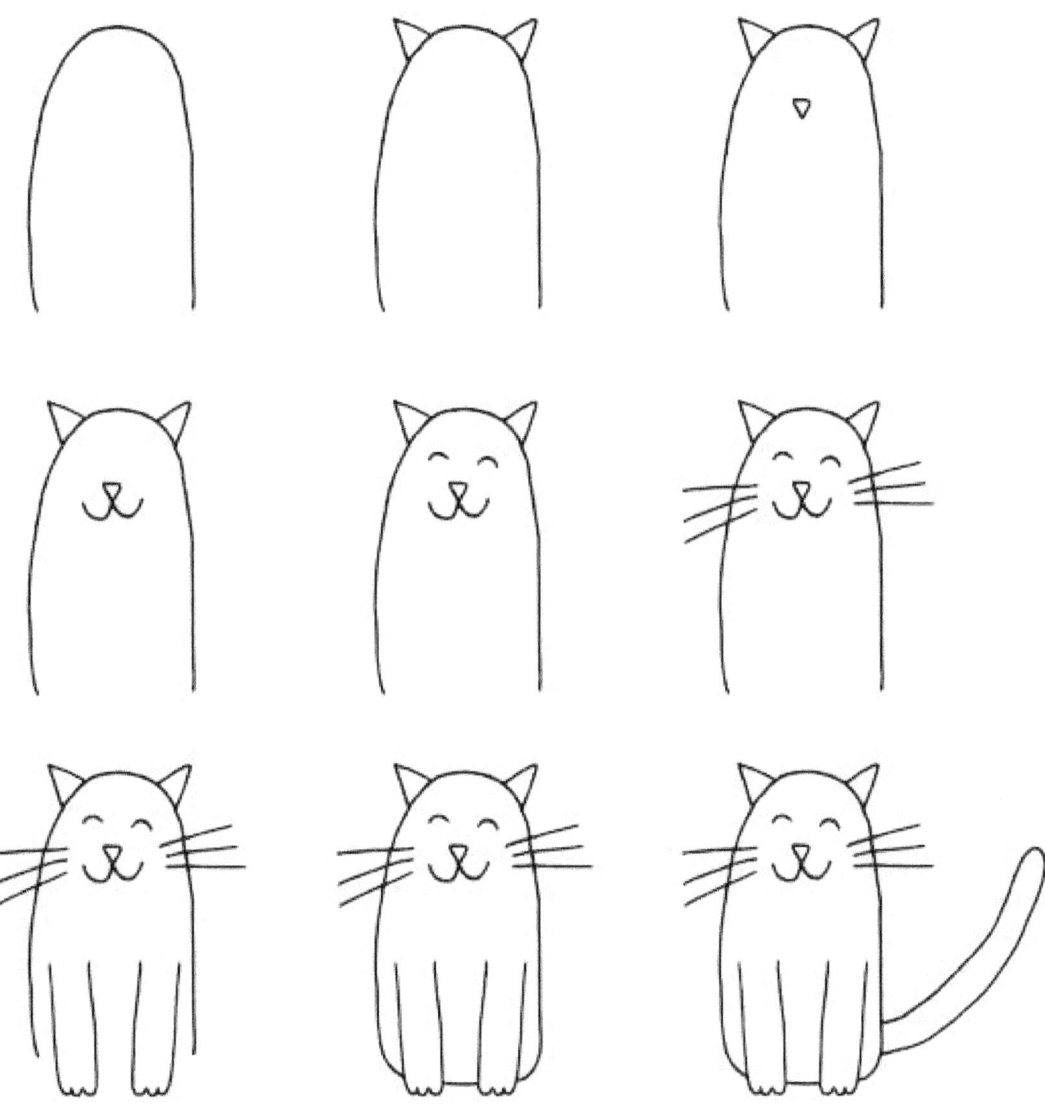

BLANK PRACTICE PAGE

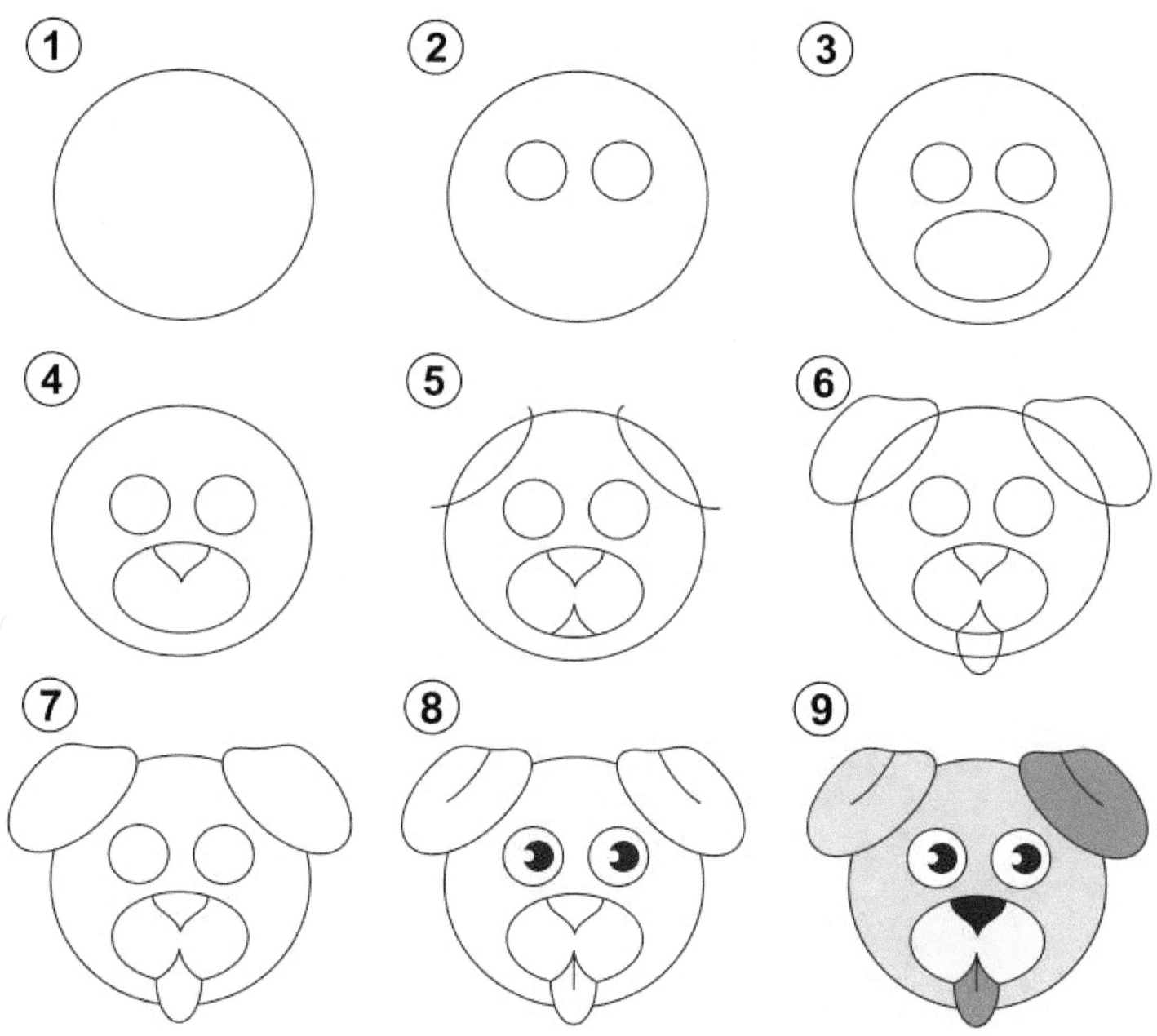

Step by step drawing tutorial

BLANK PRACTICE PAGE

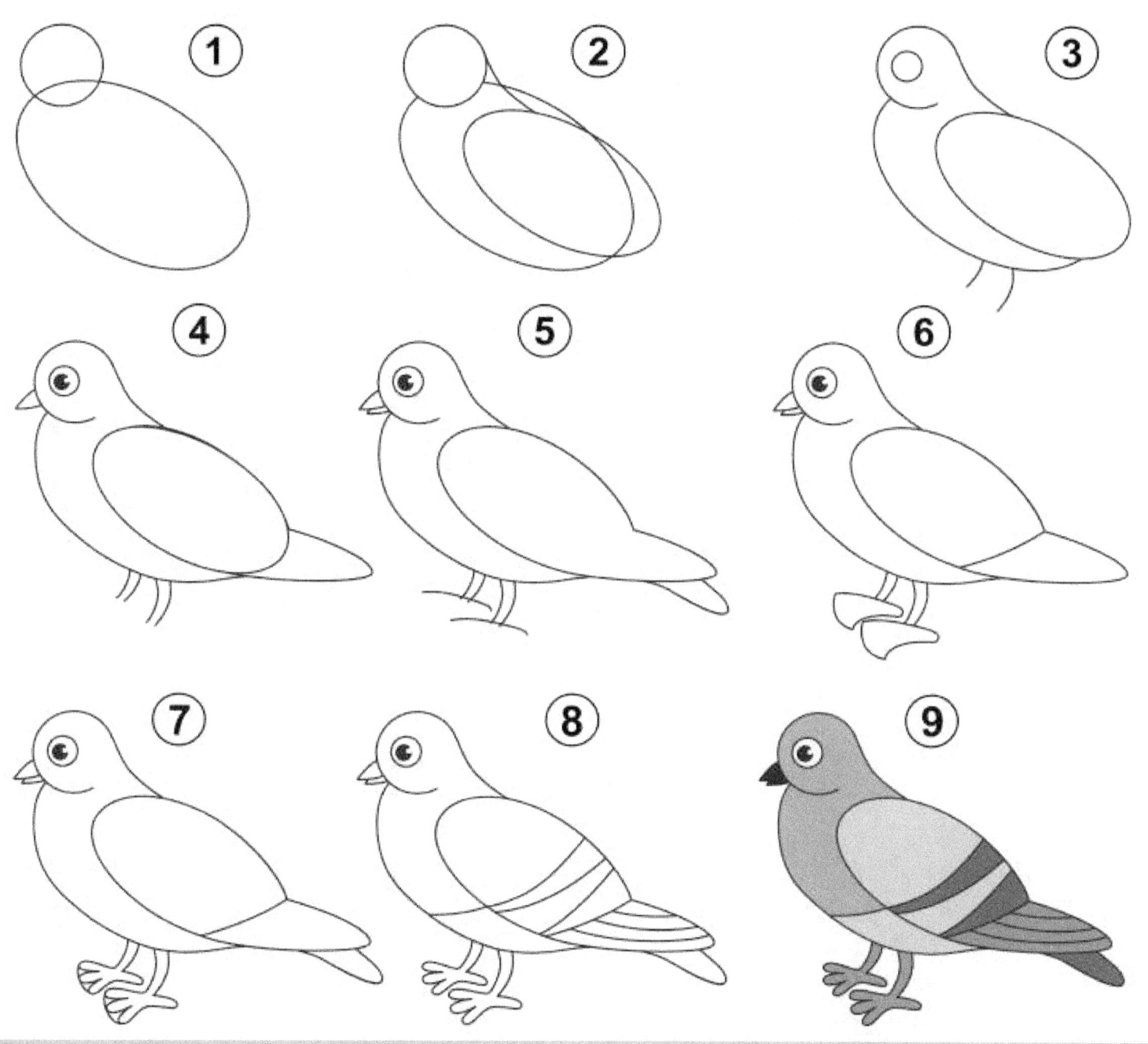

Step by step drawing tutorial

BLANK PRACTICE PAGE

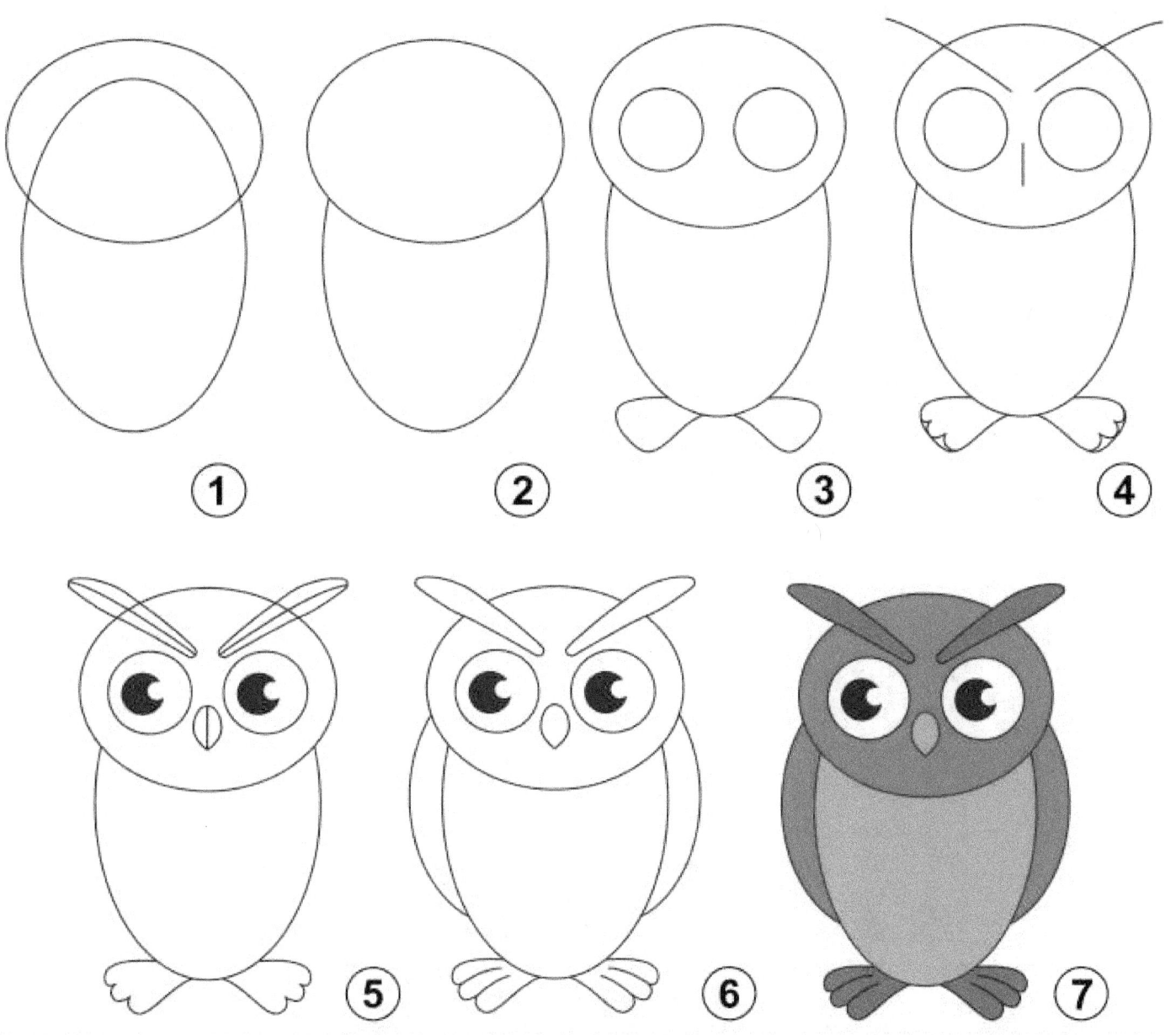
Step by step drawing tutorial

BLANK PRACTICE PAGE

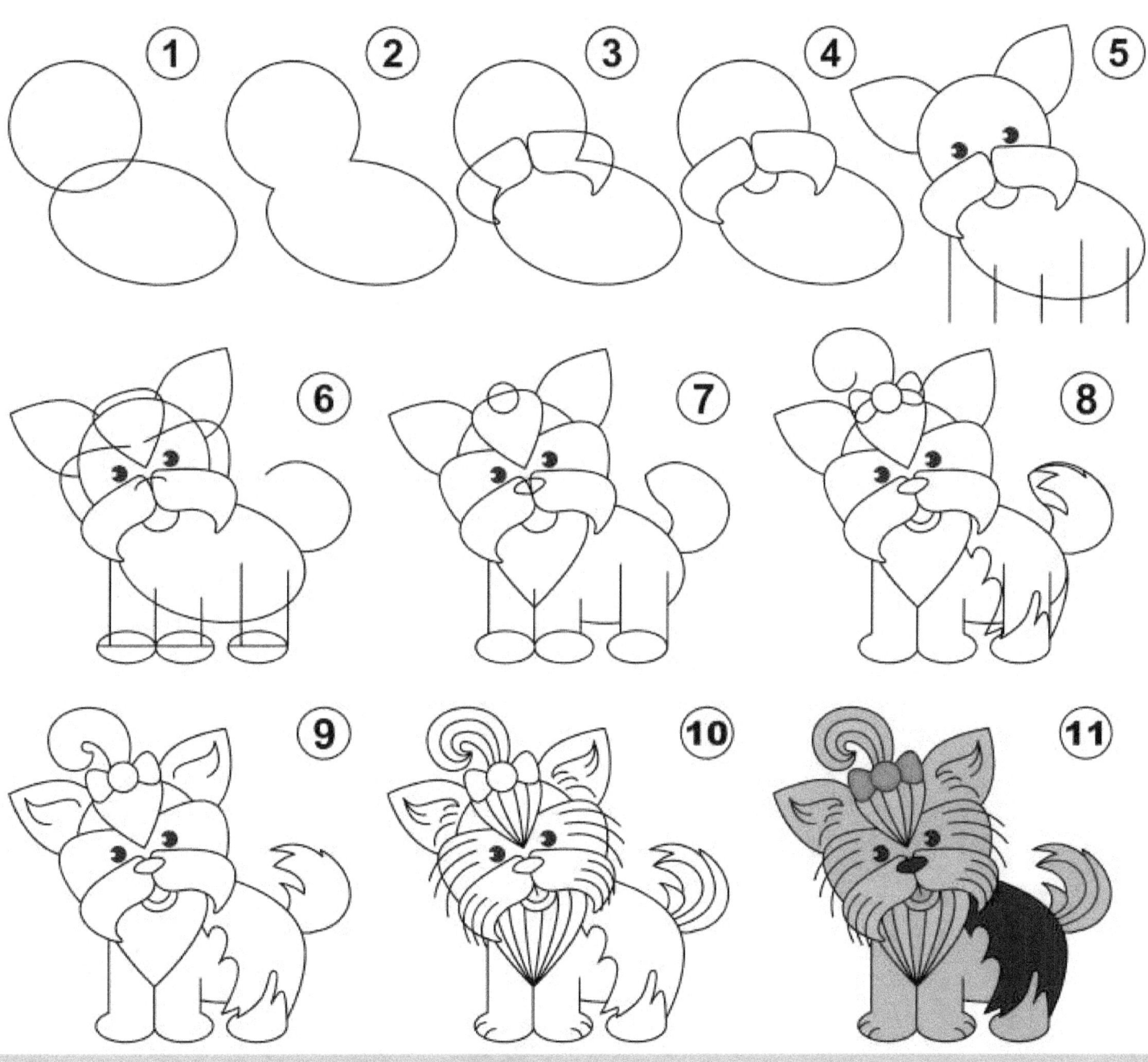
Step by step drawing tutorial

BLANK PRACTICE PAGE

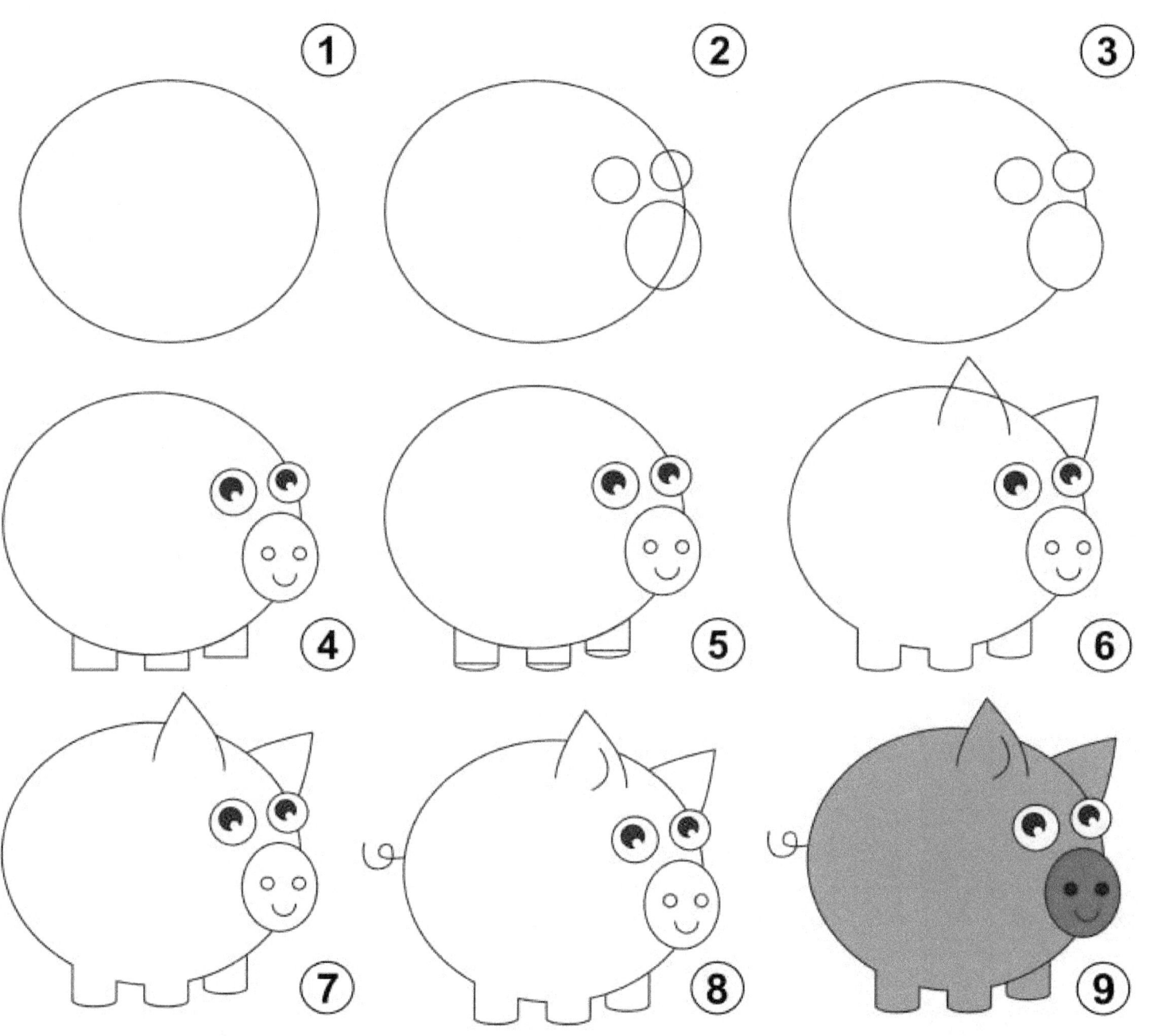

Step by step drawing tutorial

BLANK PRACTICE PAGE

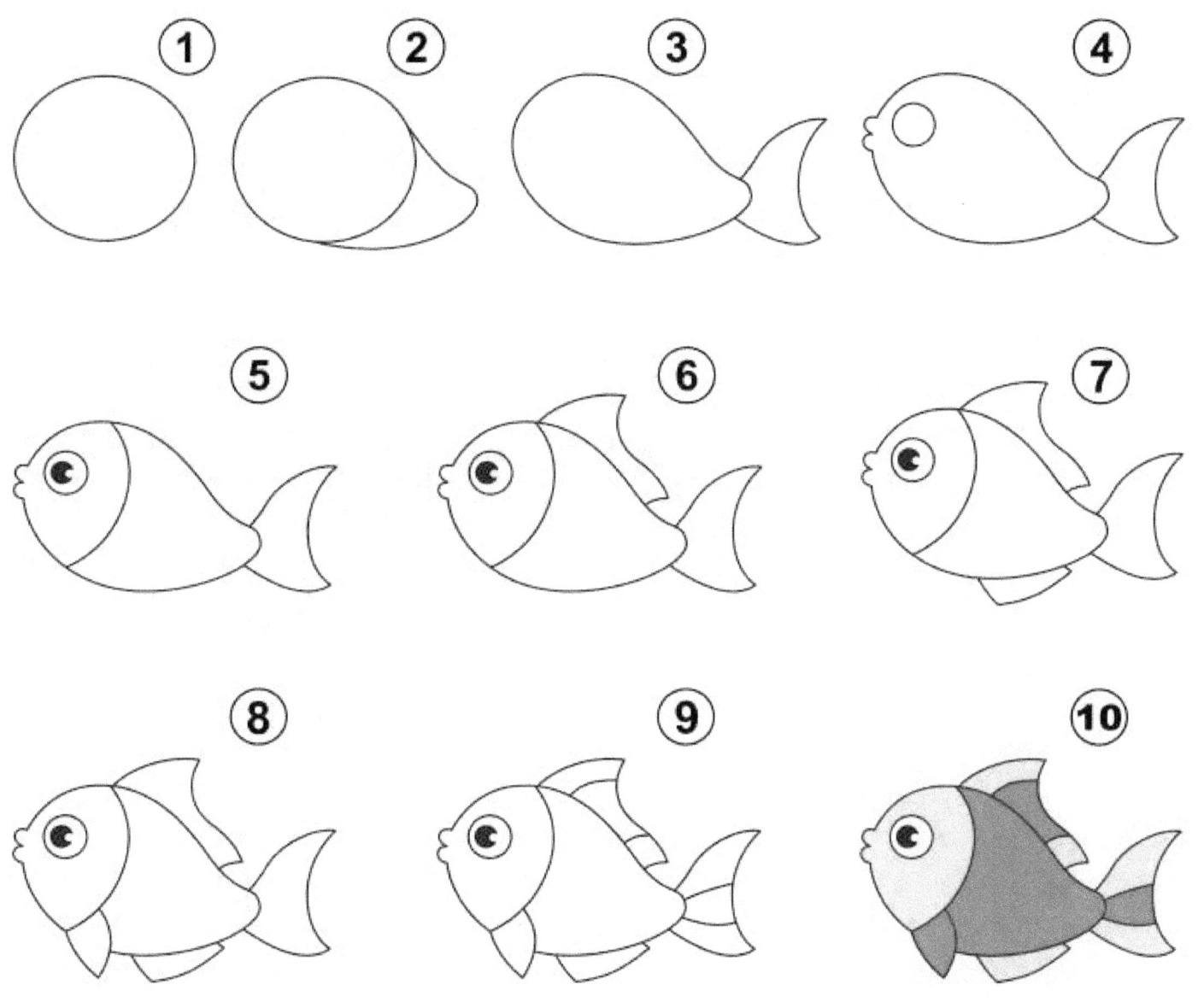

Step by step drawing tutorial

BLANK PRACTICE PAGE

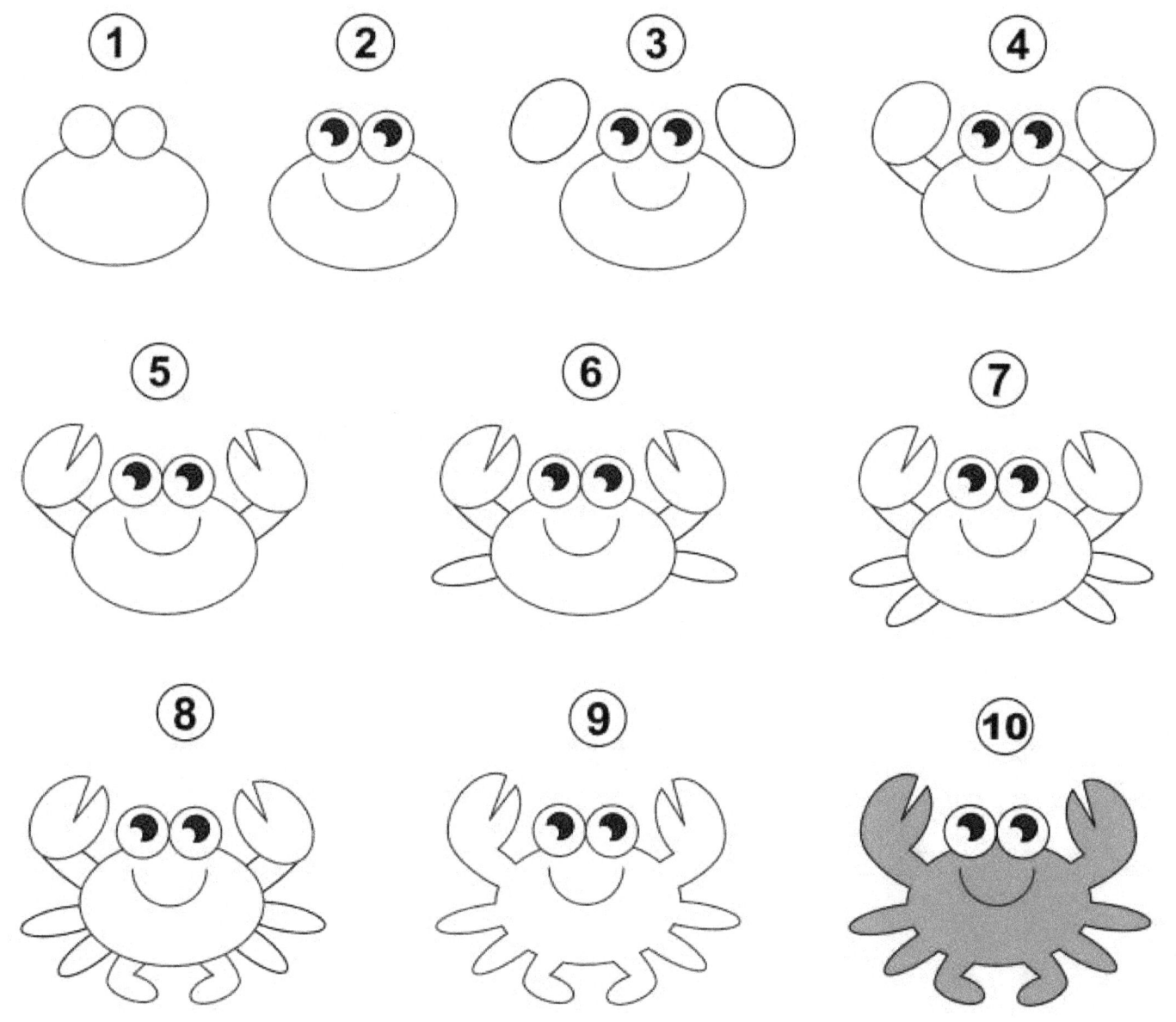

Step by step drawing tutorial

BLANK PRACTICE PAGE

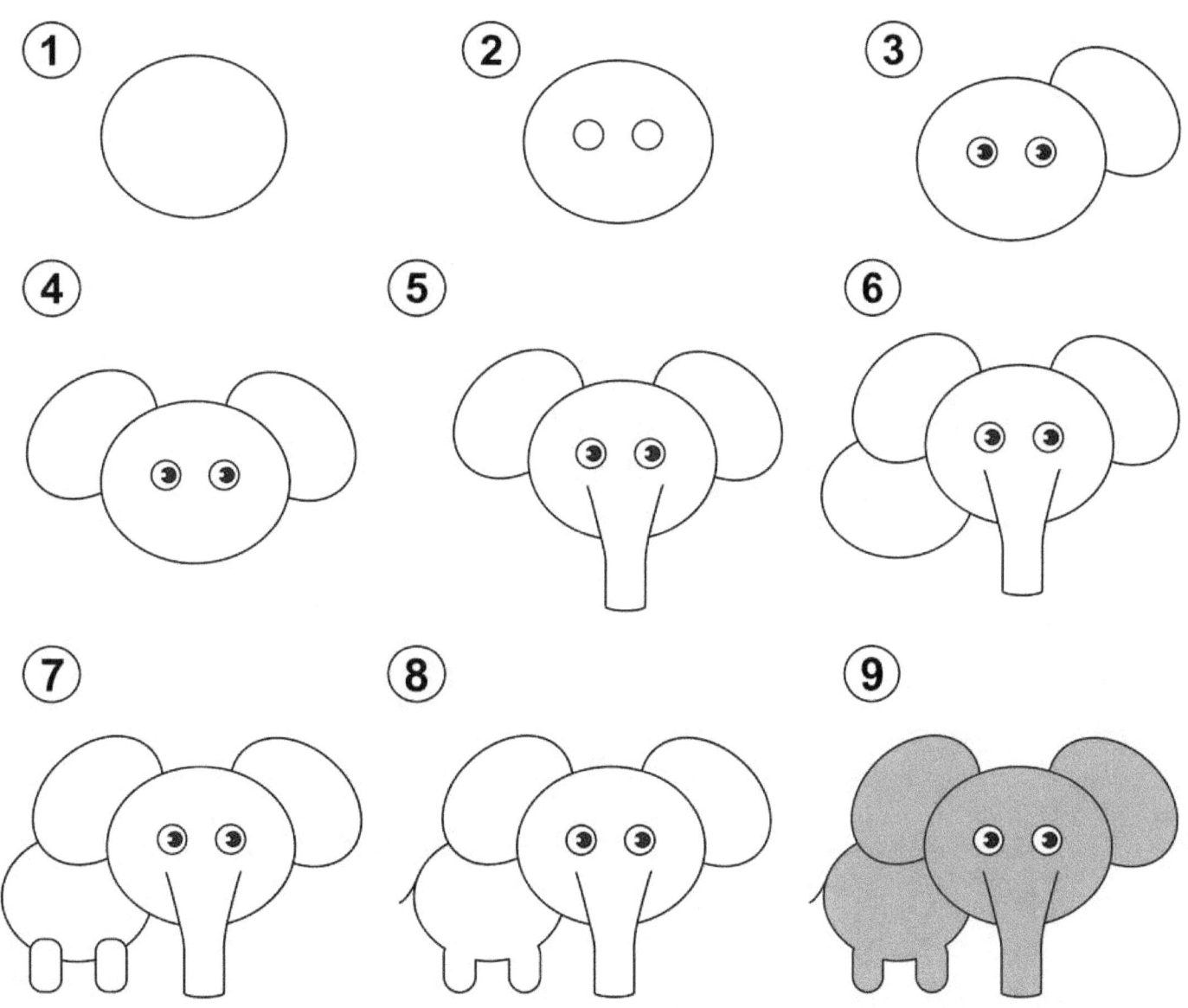

Step by step drawing lesson

BLANK PRACTICE PAGE

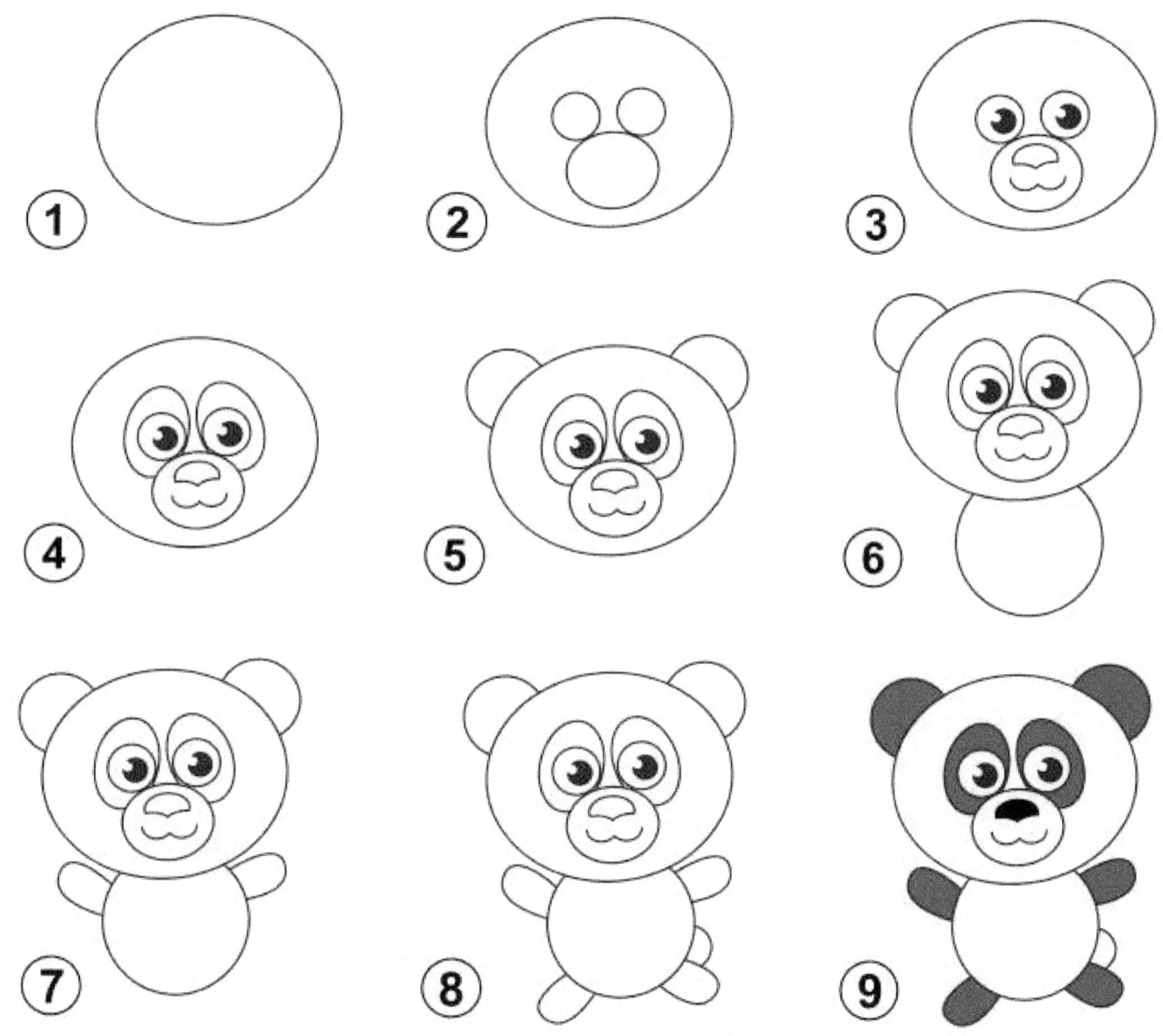

Step by step drawing tutorial

BLANK PRACTICE PAGE

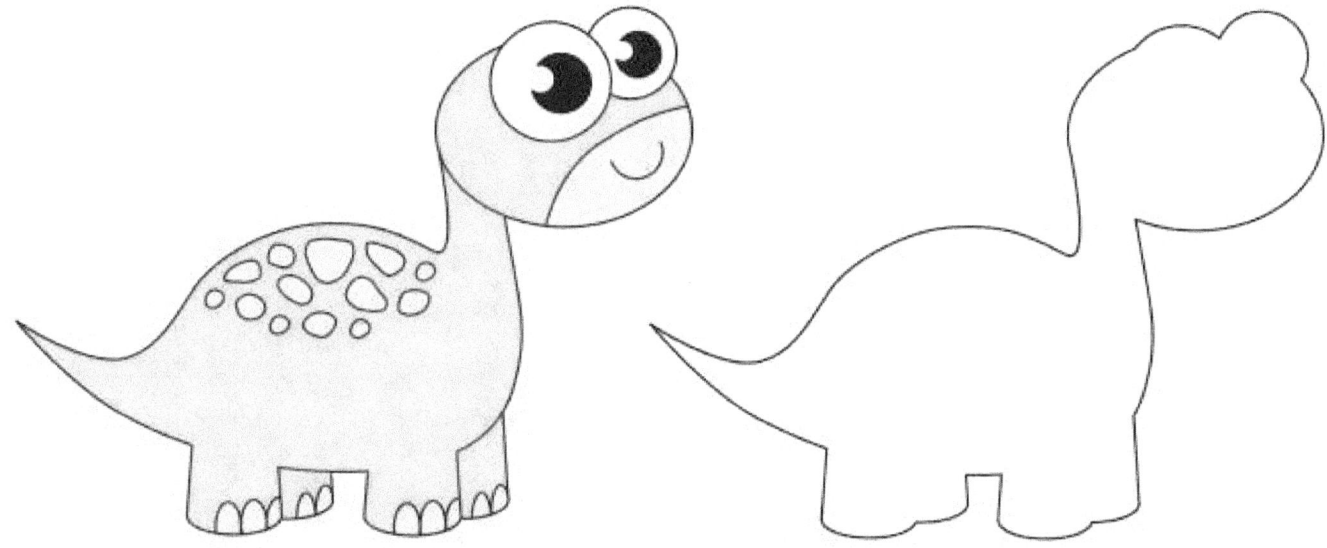

Finish the picture by sample

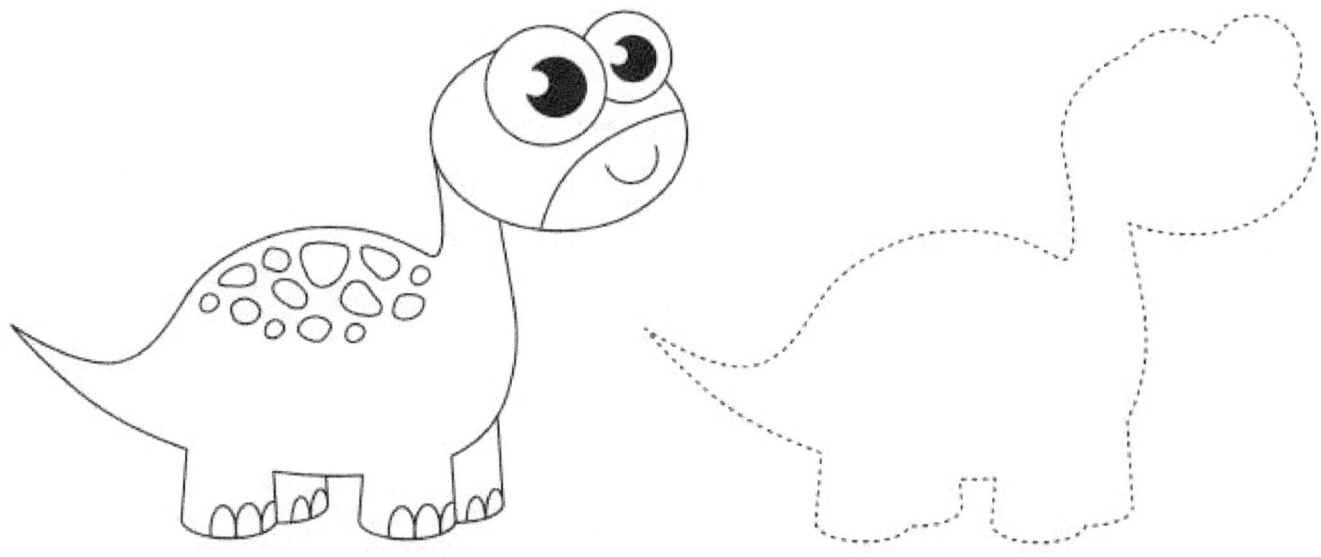

BLANK PRACTICE PAGE

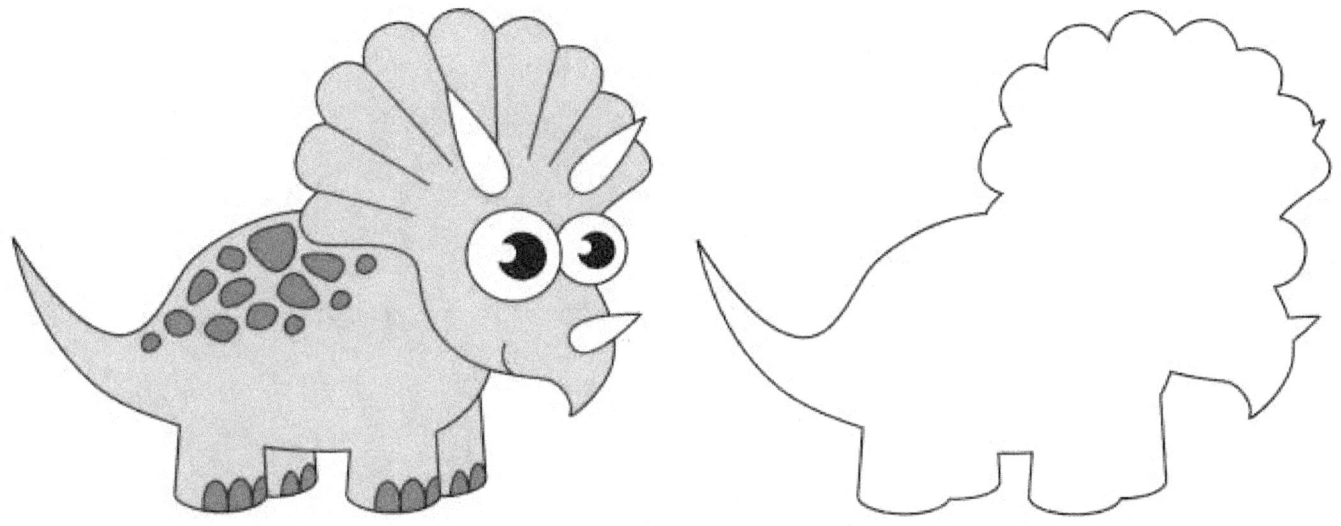

Finish the picture by sample

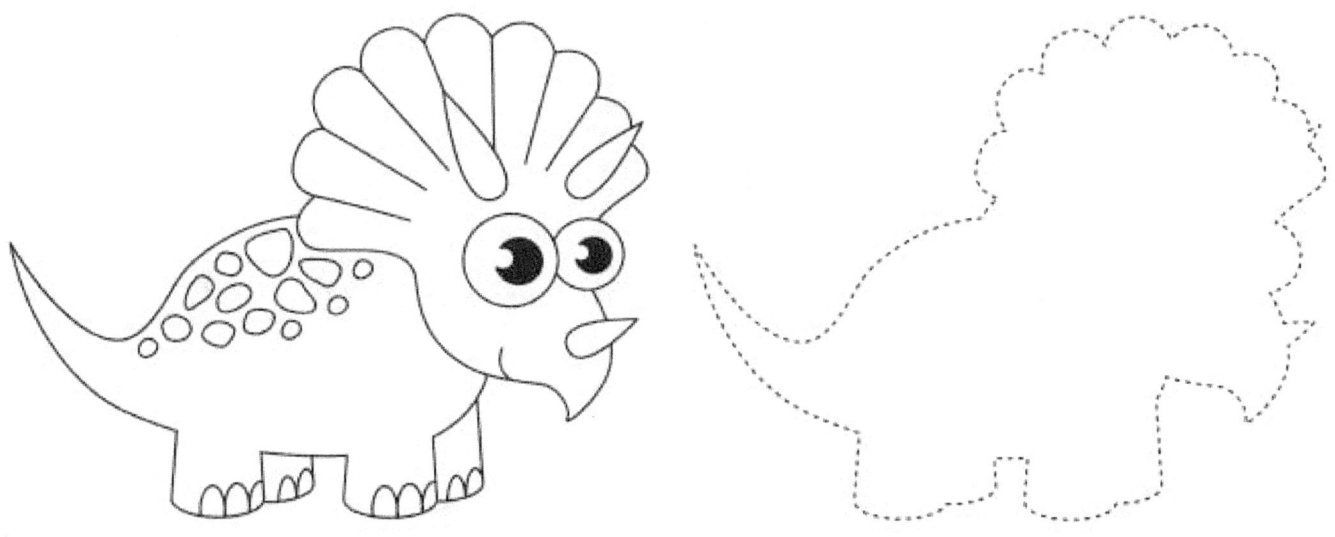

BLANK PRACTICE PAGE

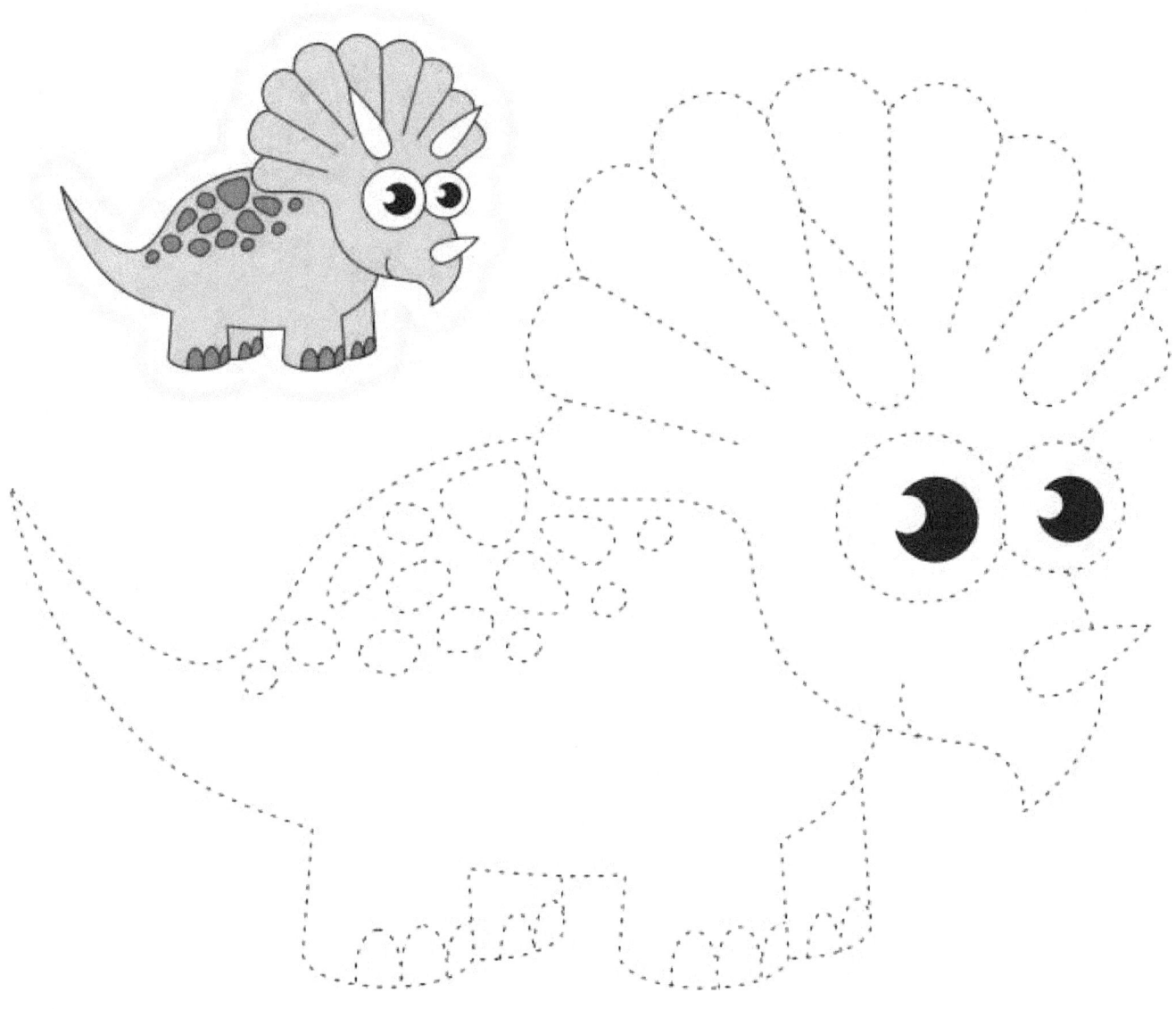

TASK 1. Restore dashed lines
2. Color the picture

BLANK PRACTICE PAGE

BLANK PRACTICE PAGE

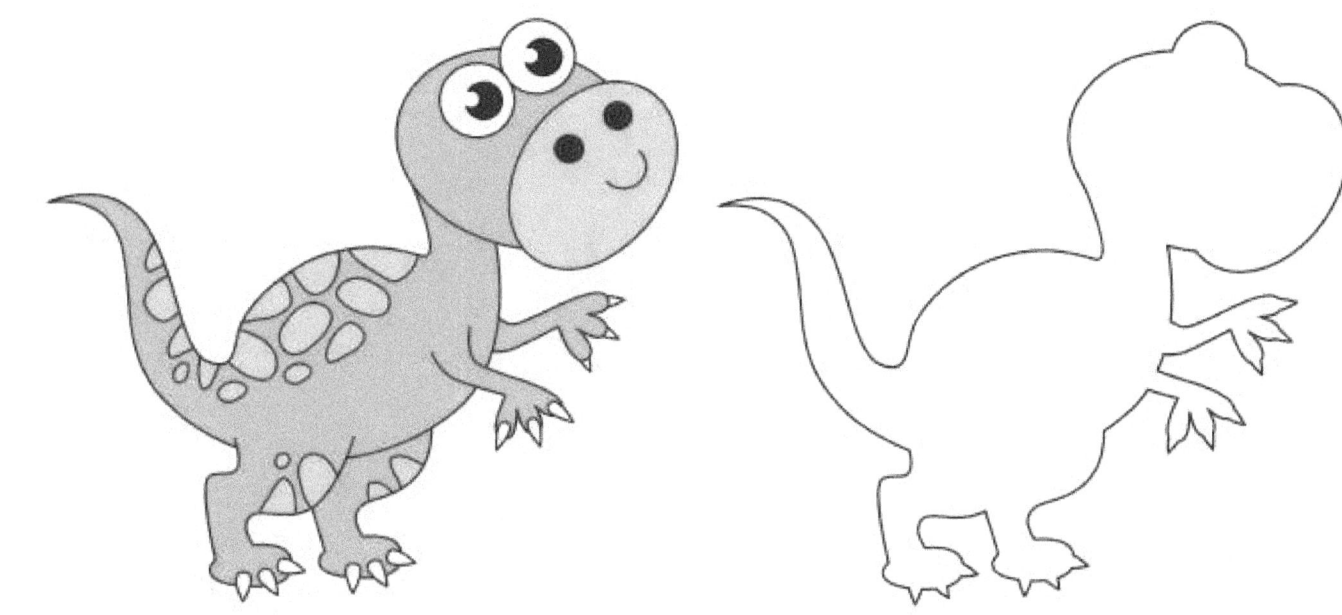

Finish the picture by sample

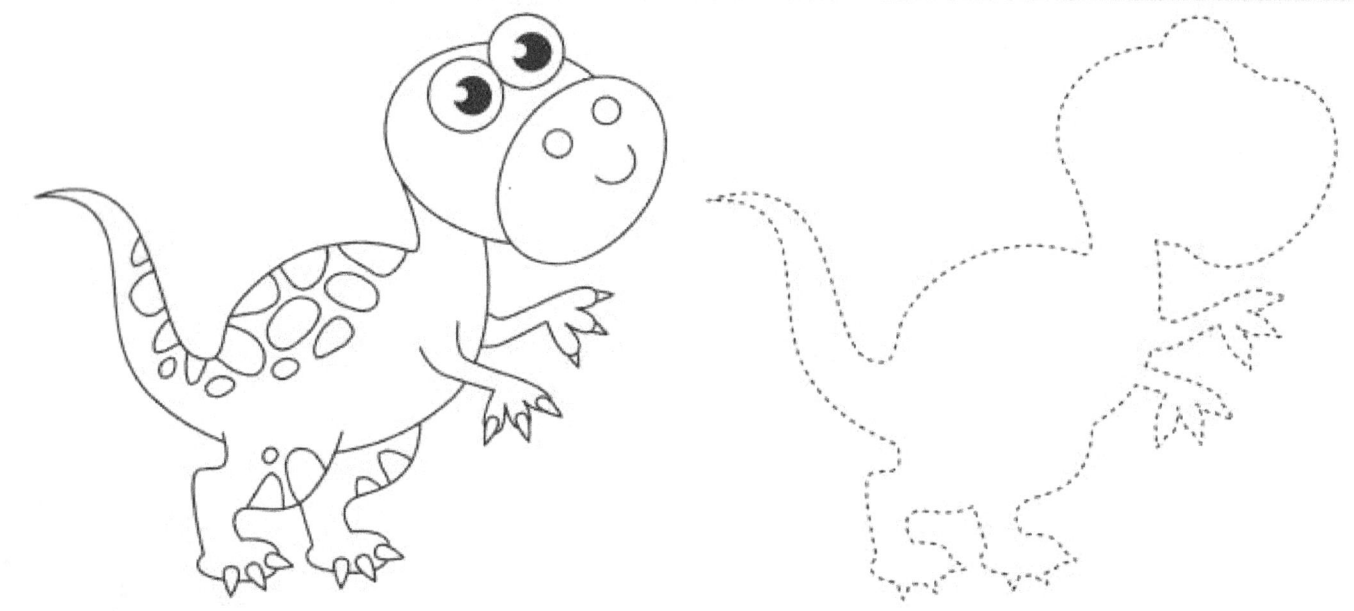

BLANK PRACTICE PAGE

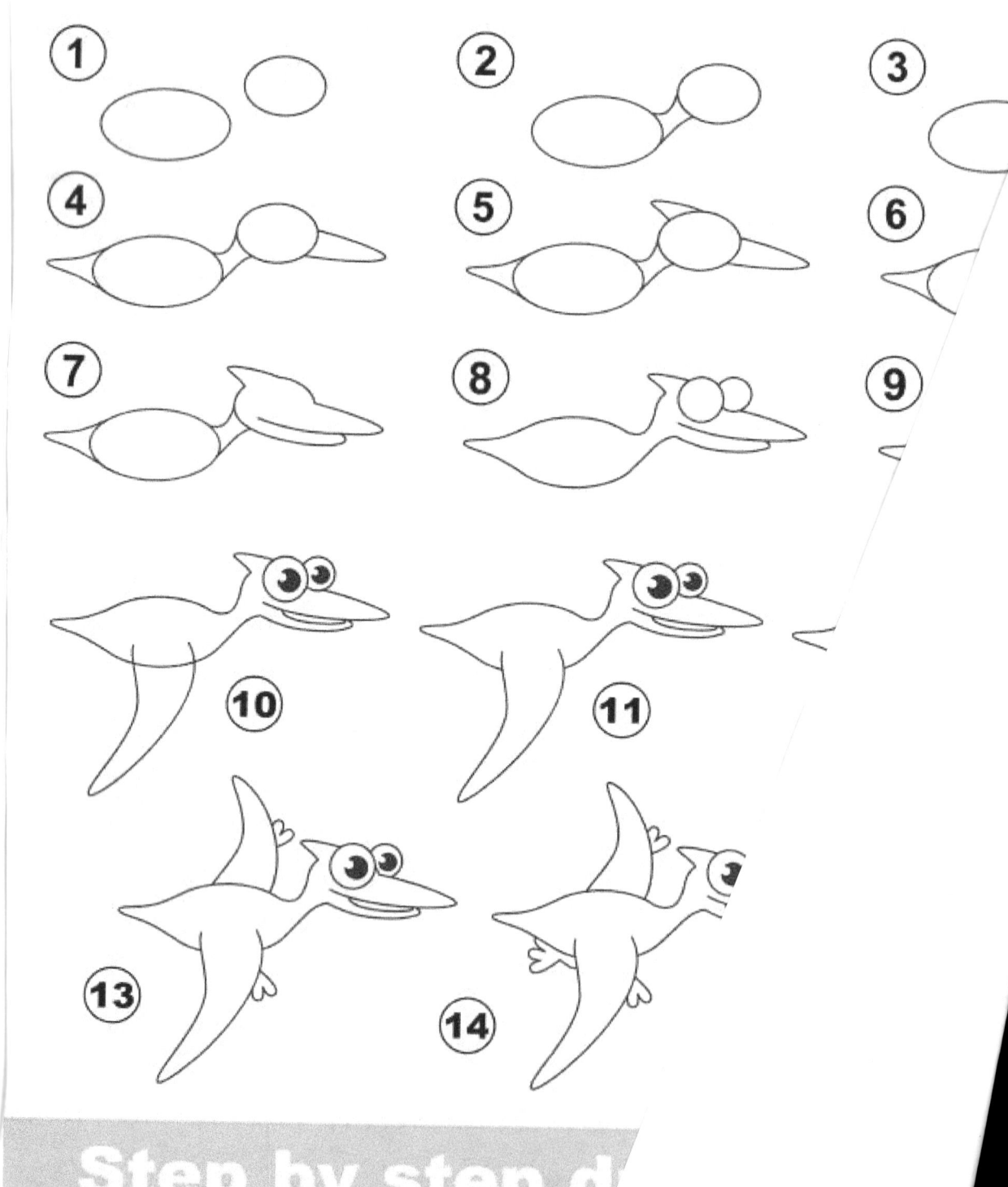

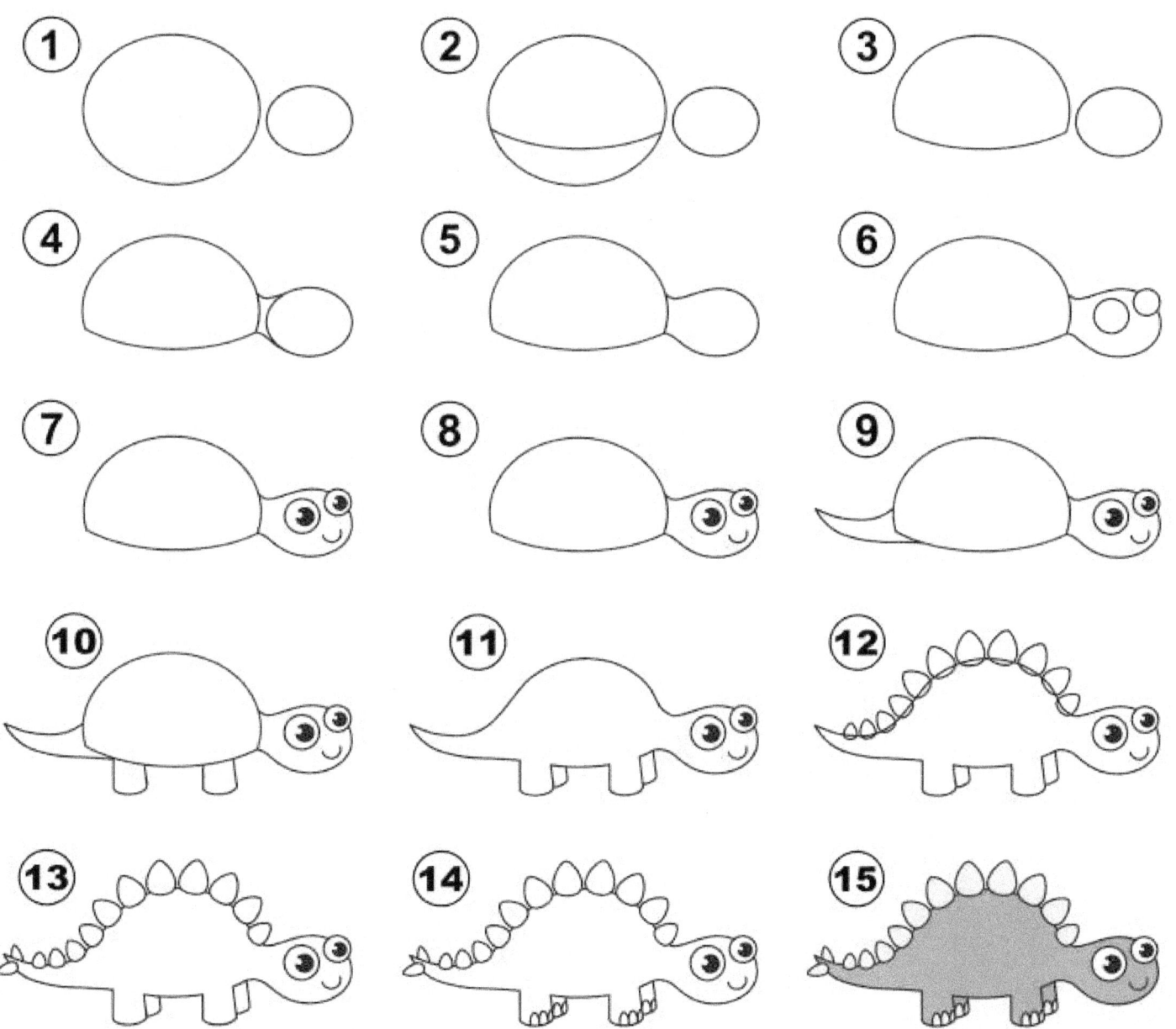

Step by step drawing tutorial

BLANK PRACTICE PAGE

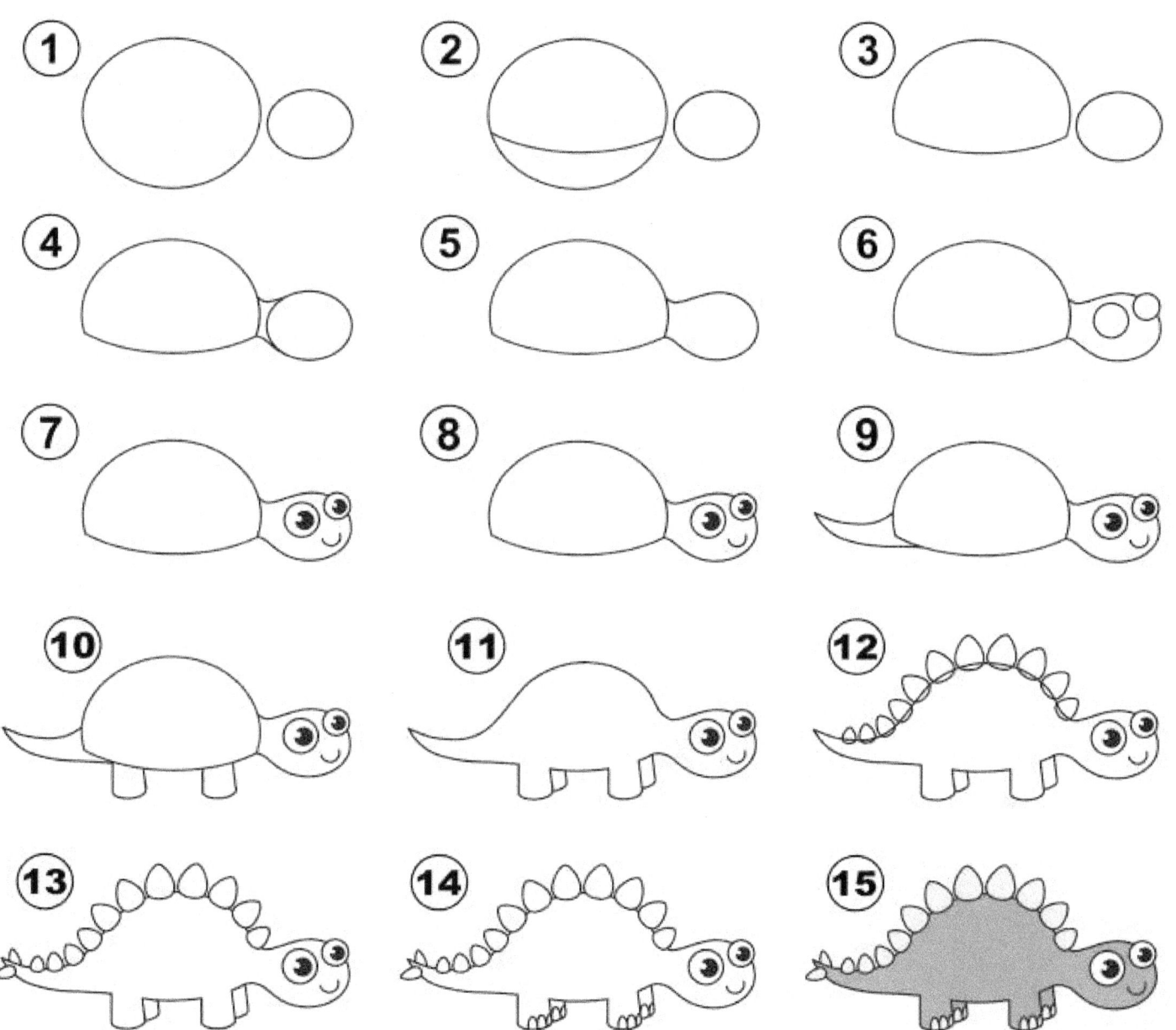

Step by step drawing tutorial

BLANK PRACTICE PAGE

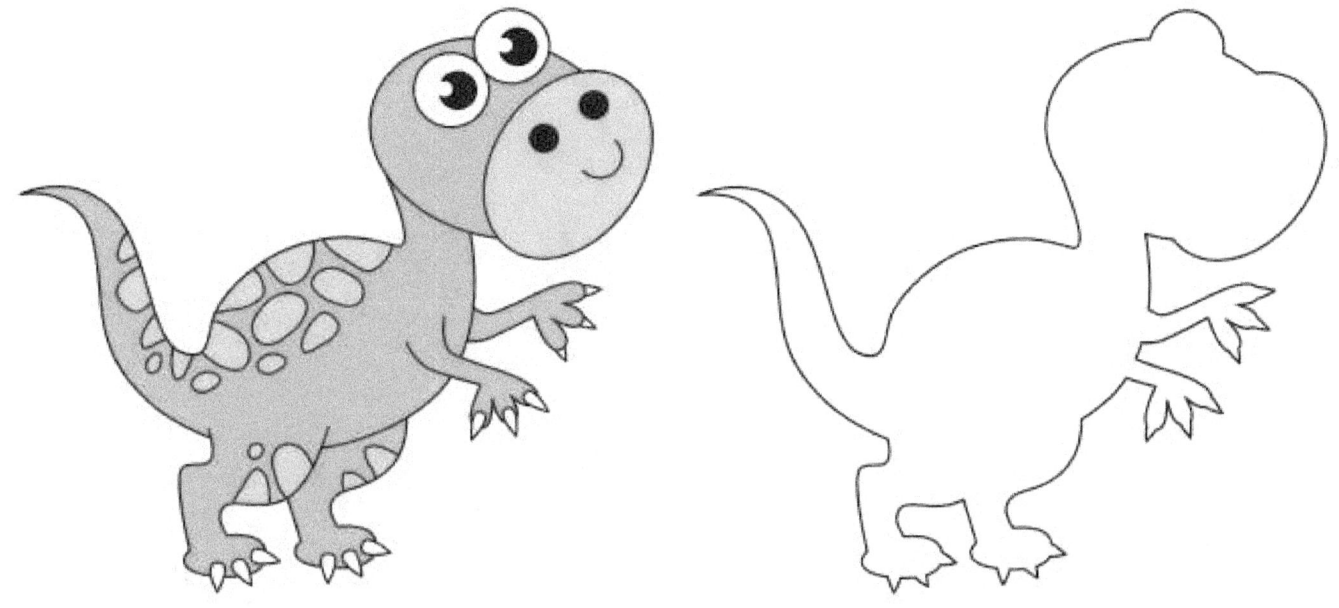

Finish the picture by sample

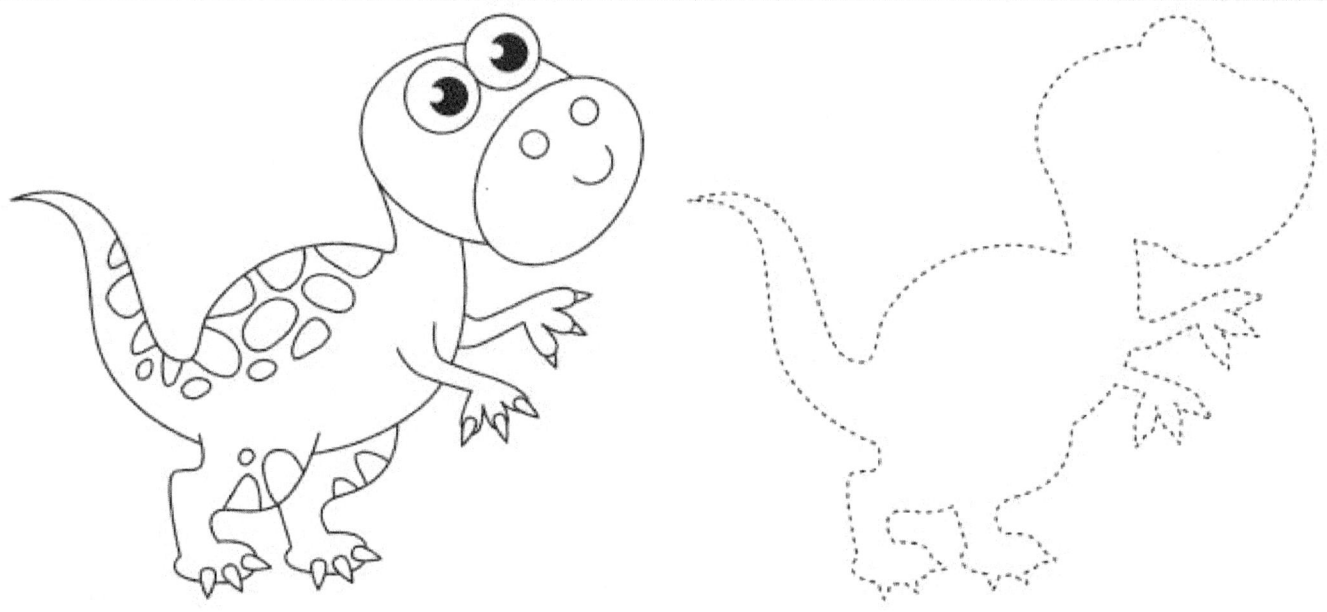

BLANK PRACTICE PAGE

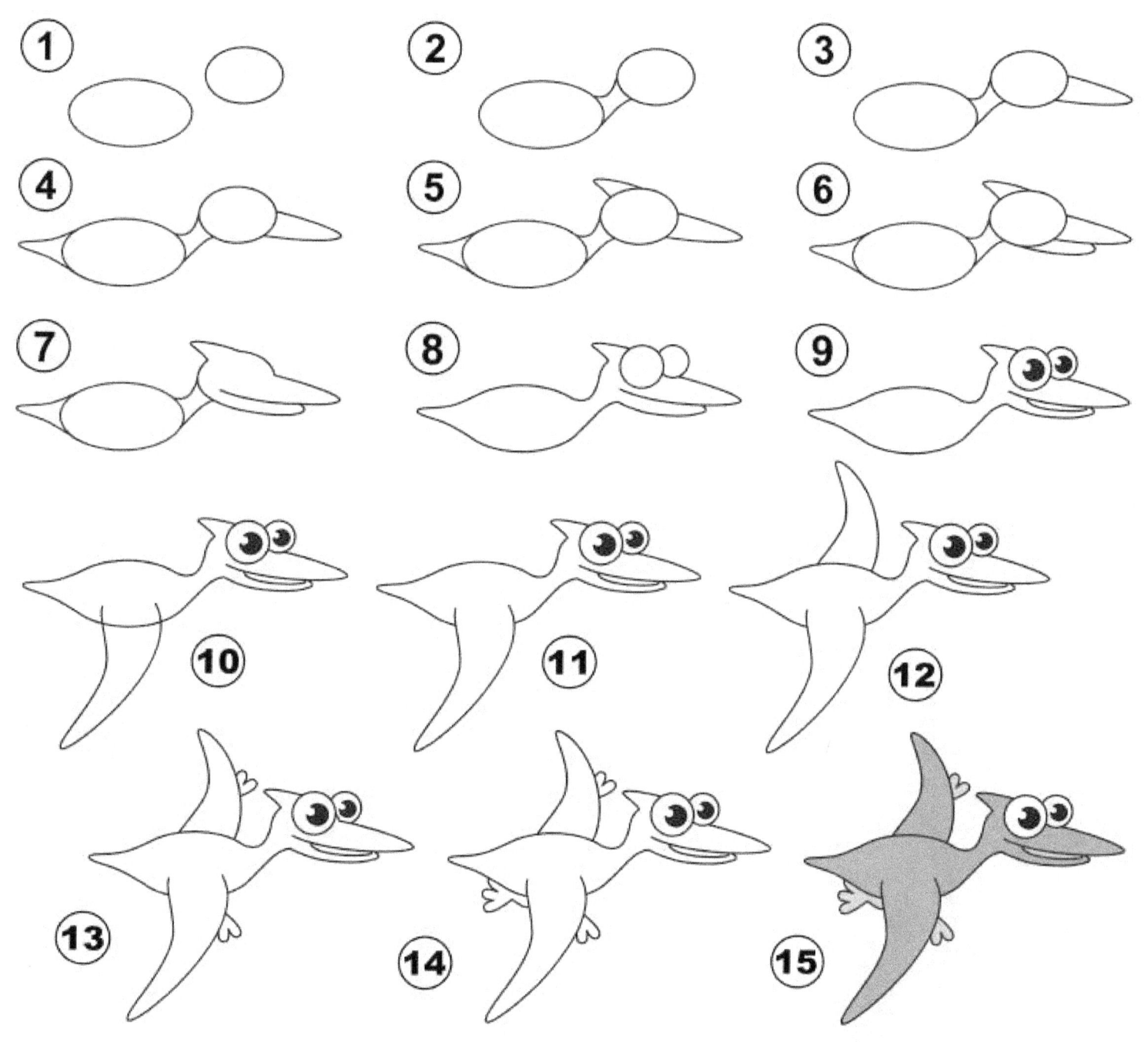
Step by step drawing tutorial

BLANK PRACTICE PAGE

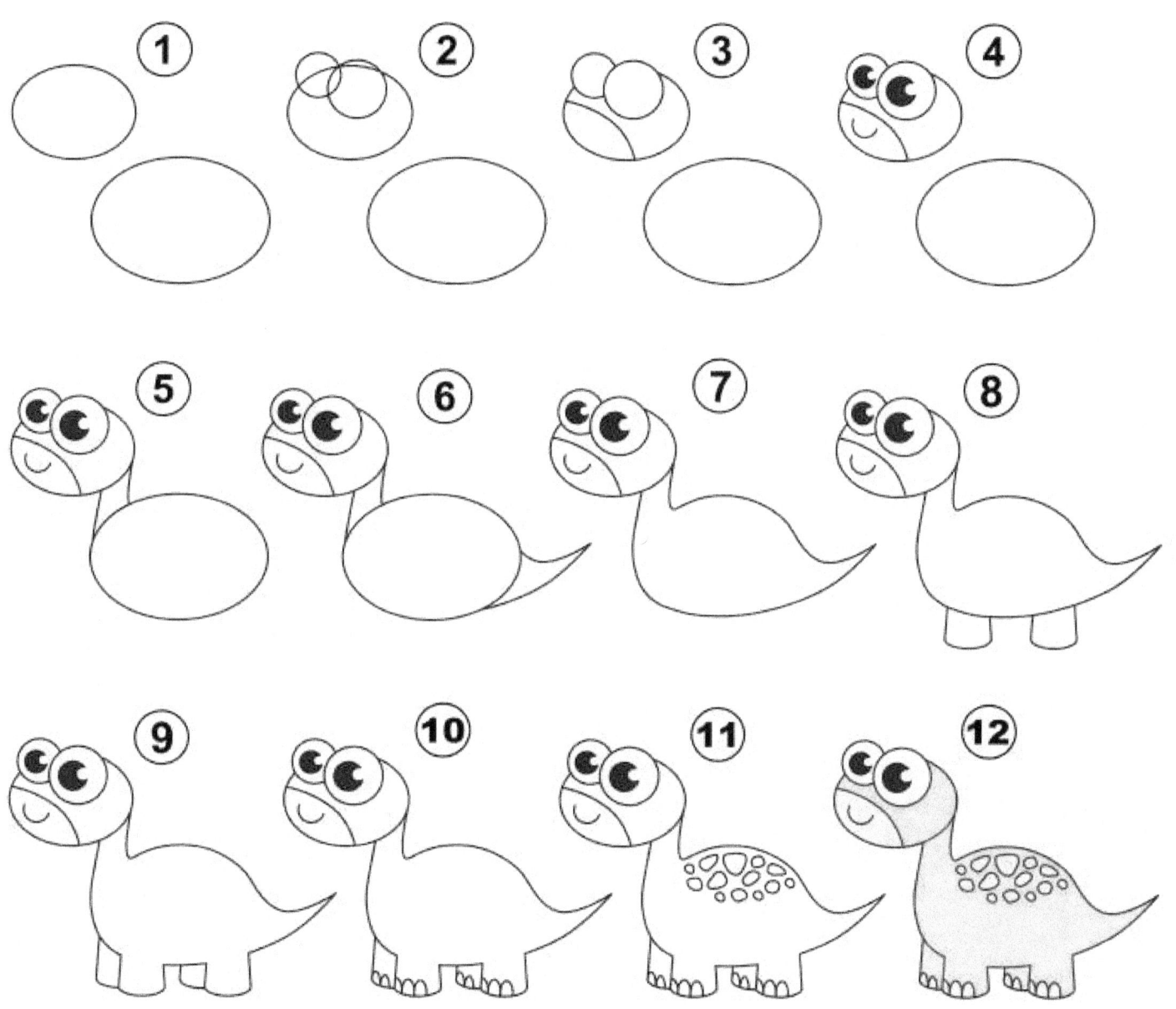

Step by step drawing tutorial

BLANK PRACTICE PAGE

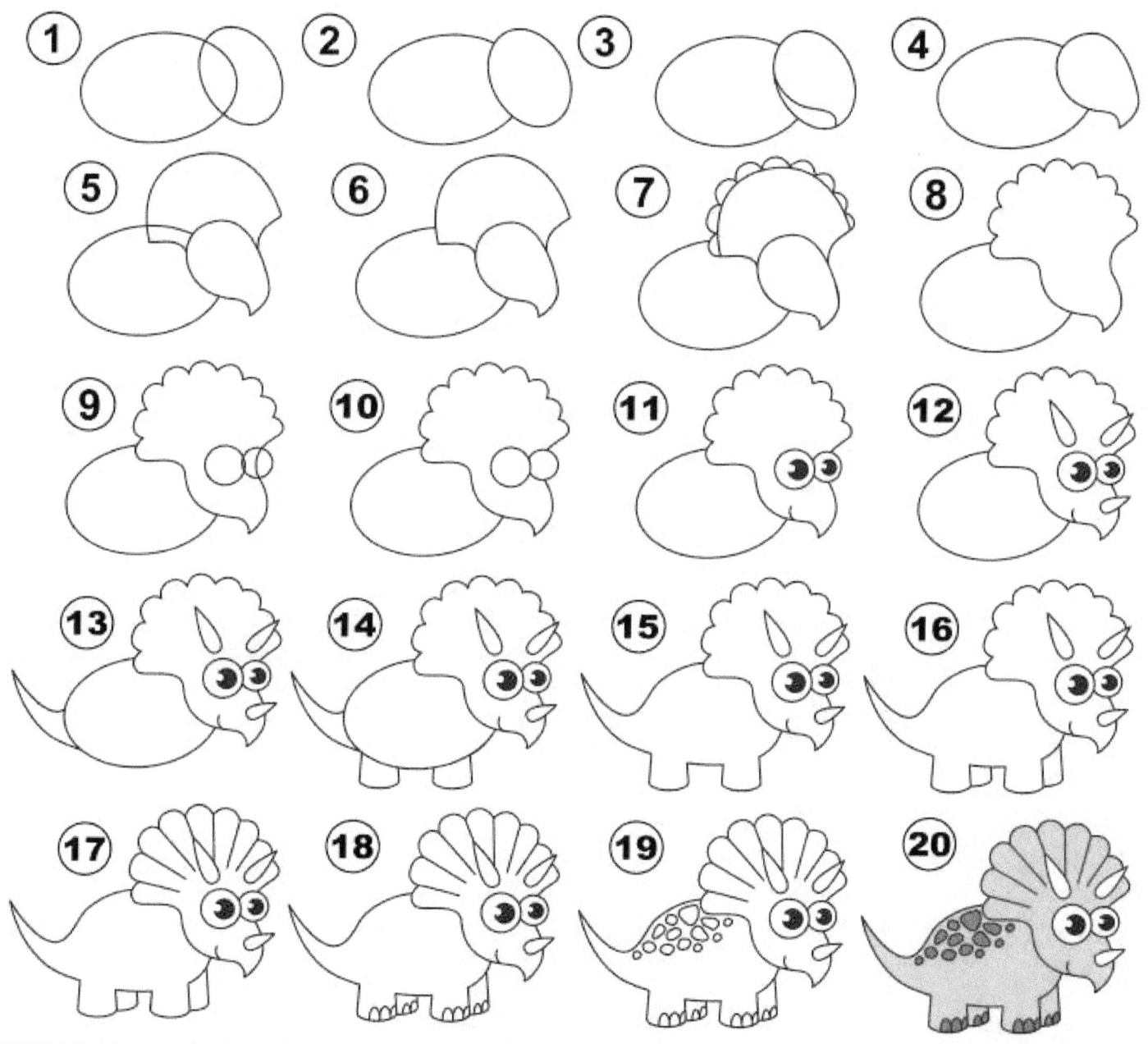

Step by step drawing tutorial

BLANK PRACTICE PAGE

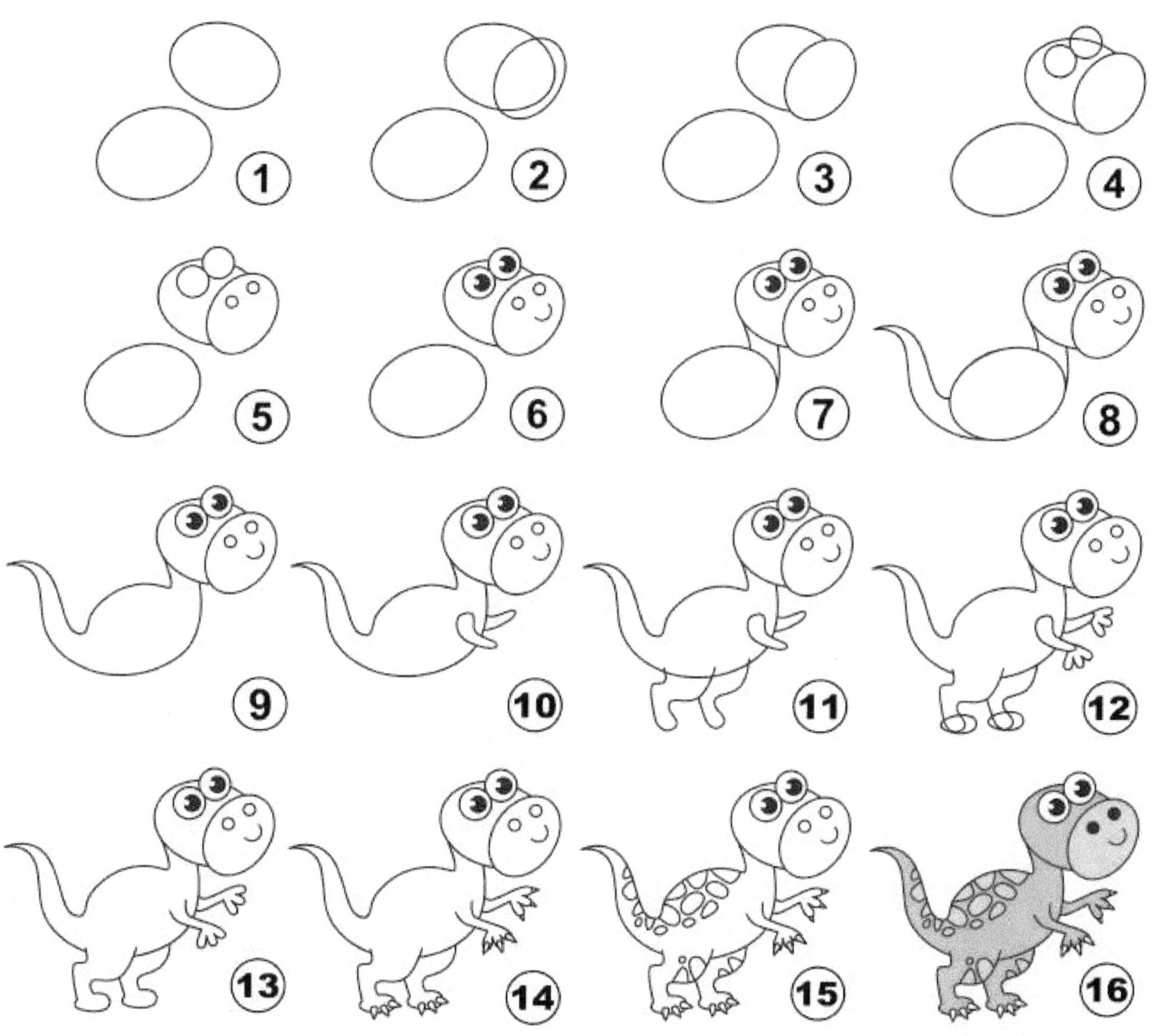
Step by step drawing tutorial

BLANK PRACTICE PAGE

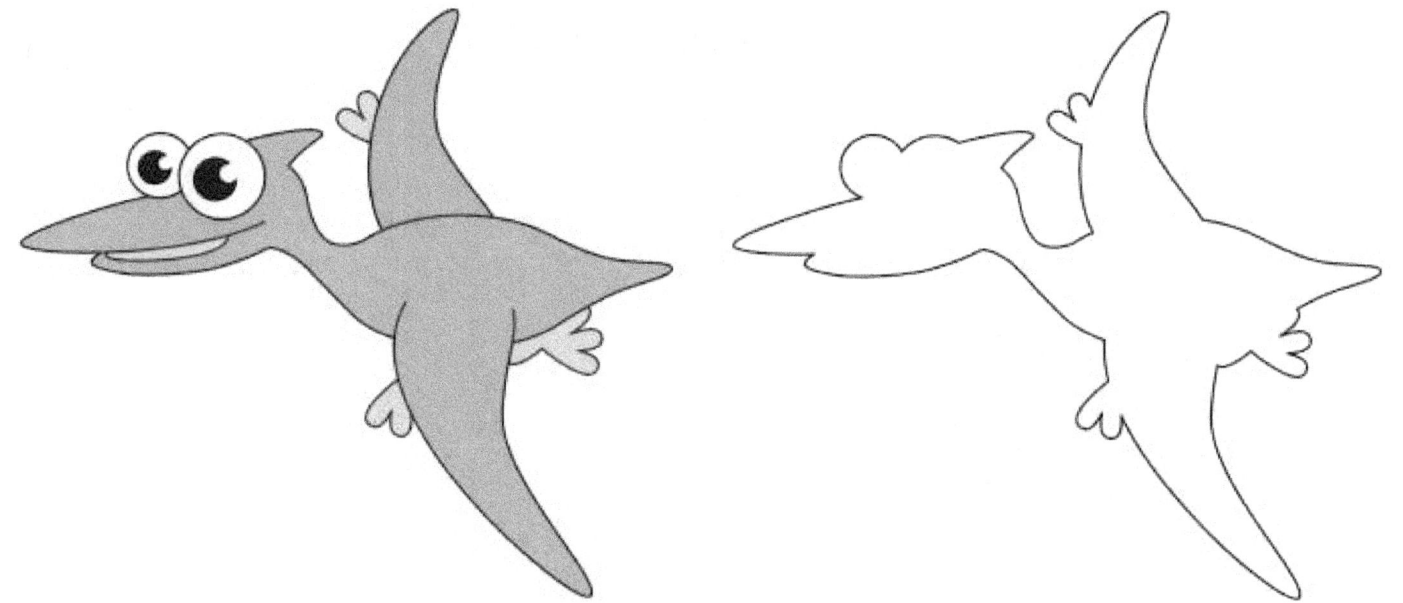

Finish the picture by sample

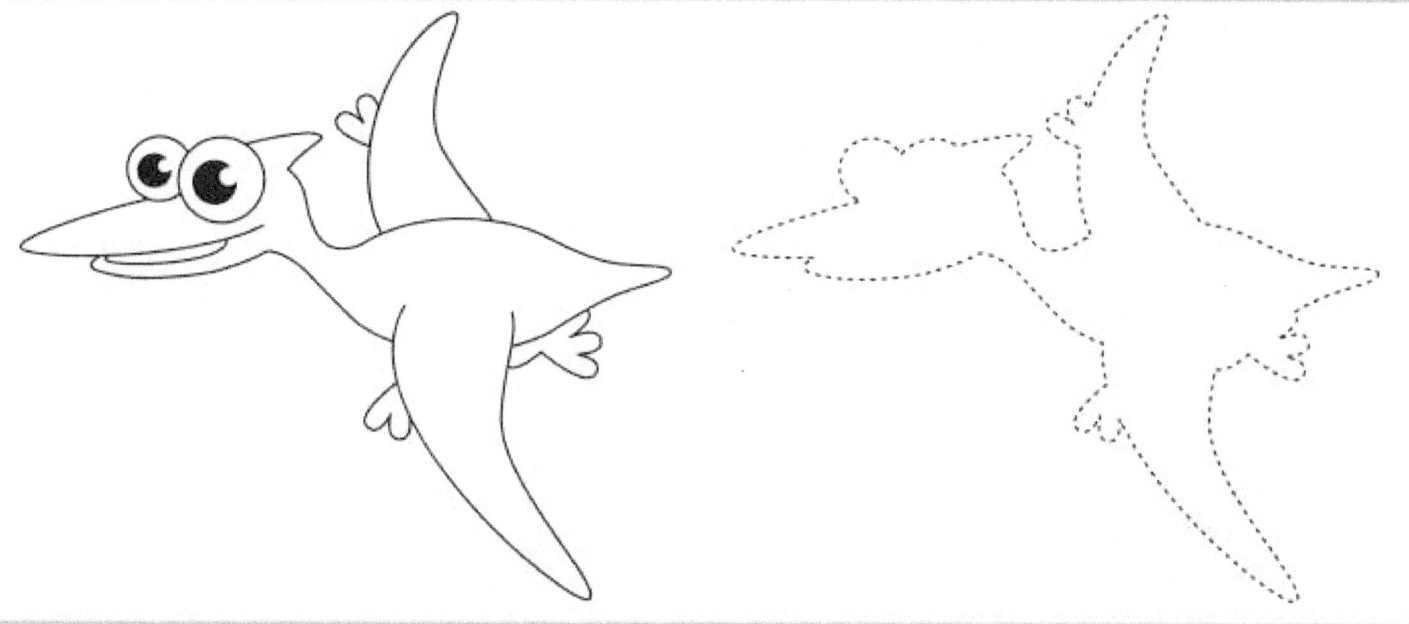

BLANK PRACTICE PAGE

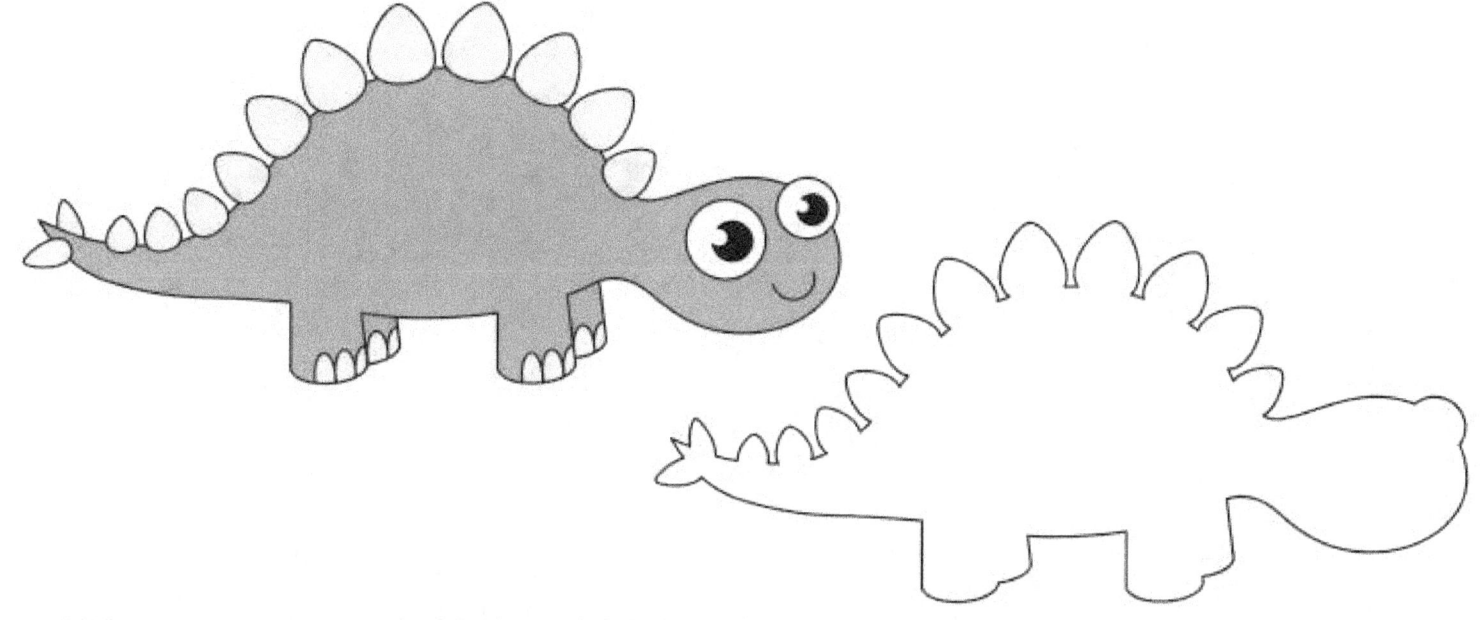

Finish the picture by sample

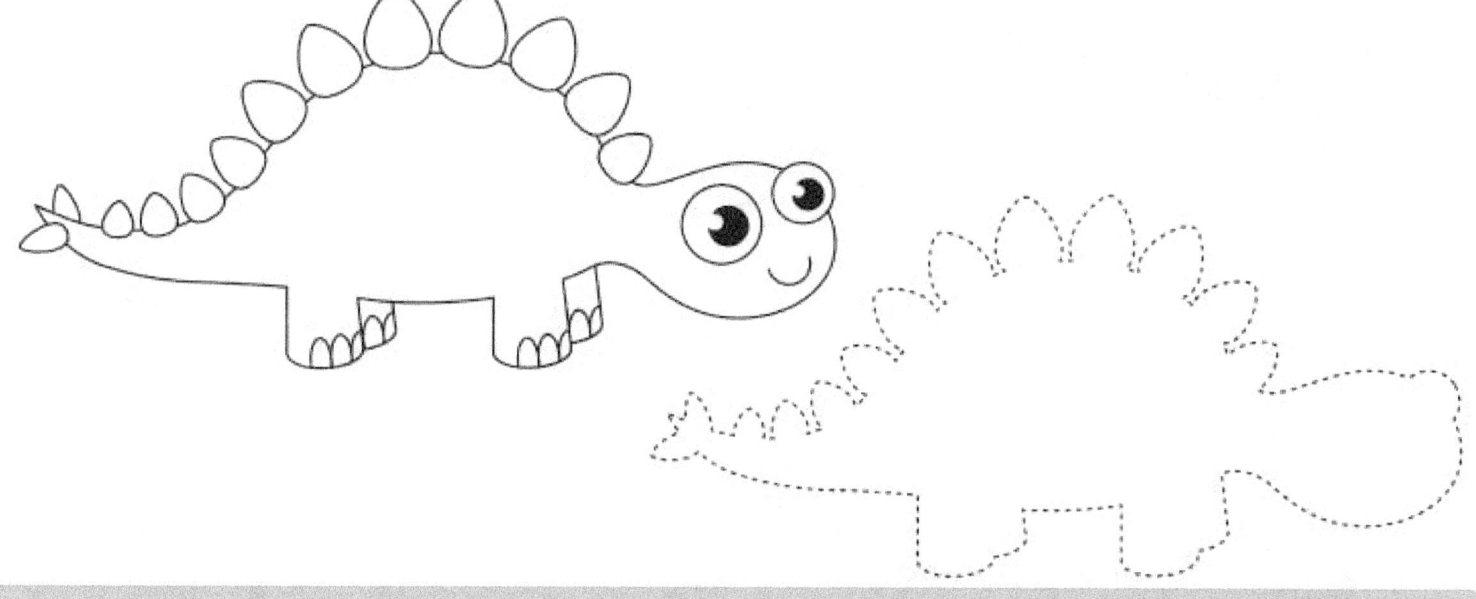

BLANK PRACTICE PAGE

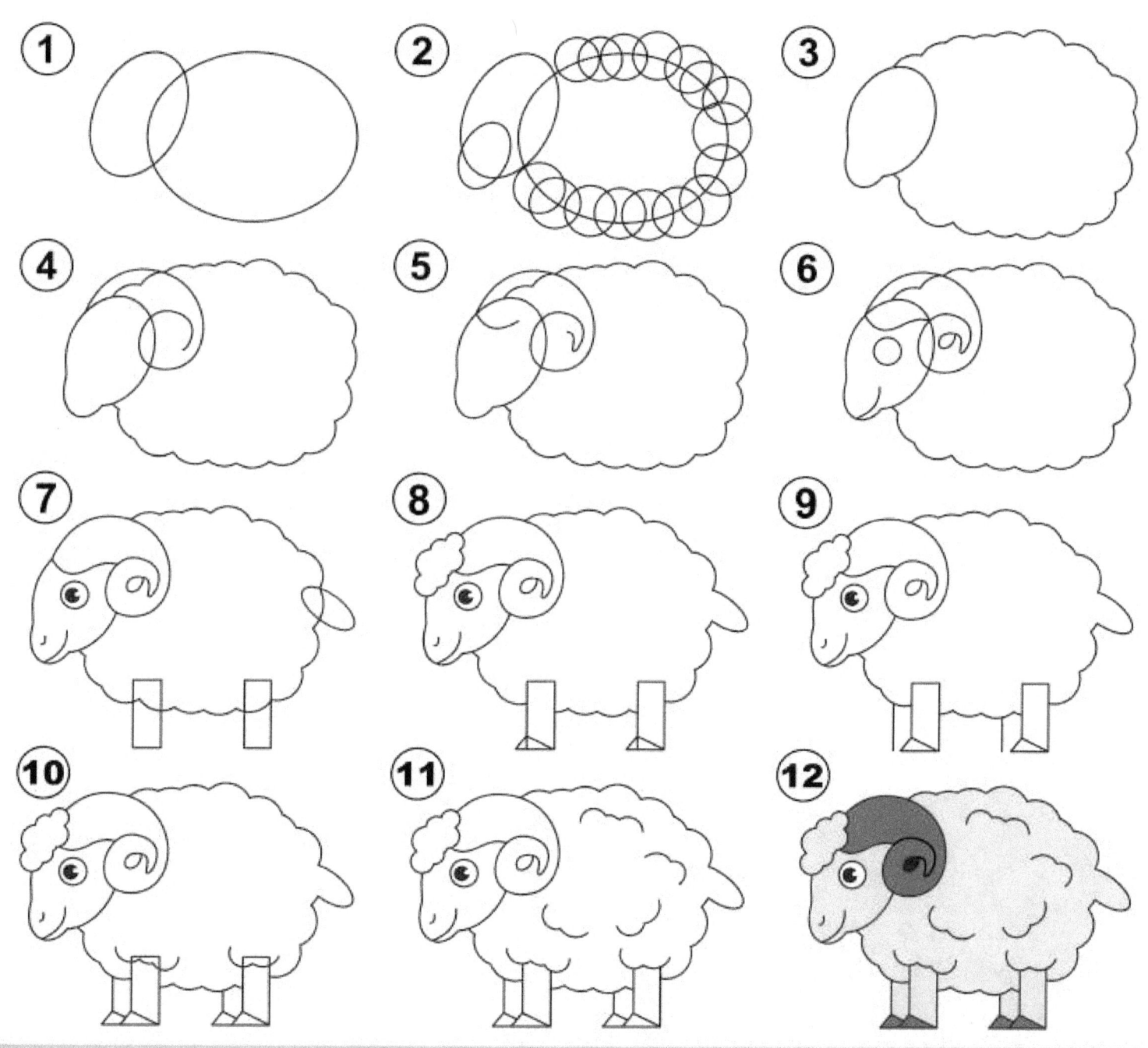

Step by step drawing tutorial

BLANK PRACTICE PAGE

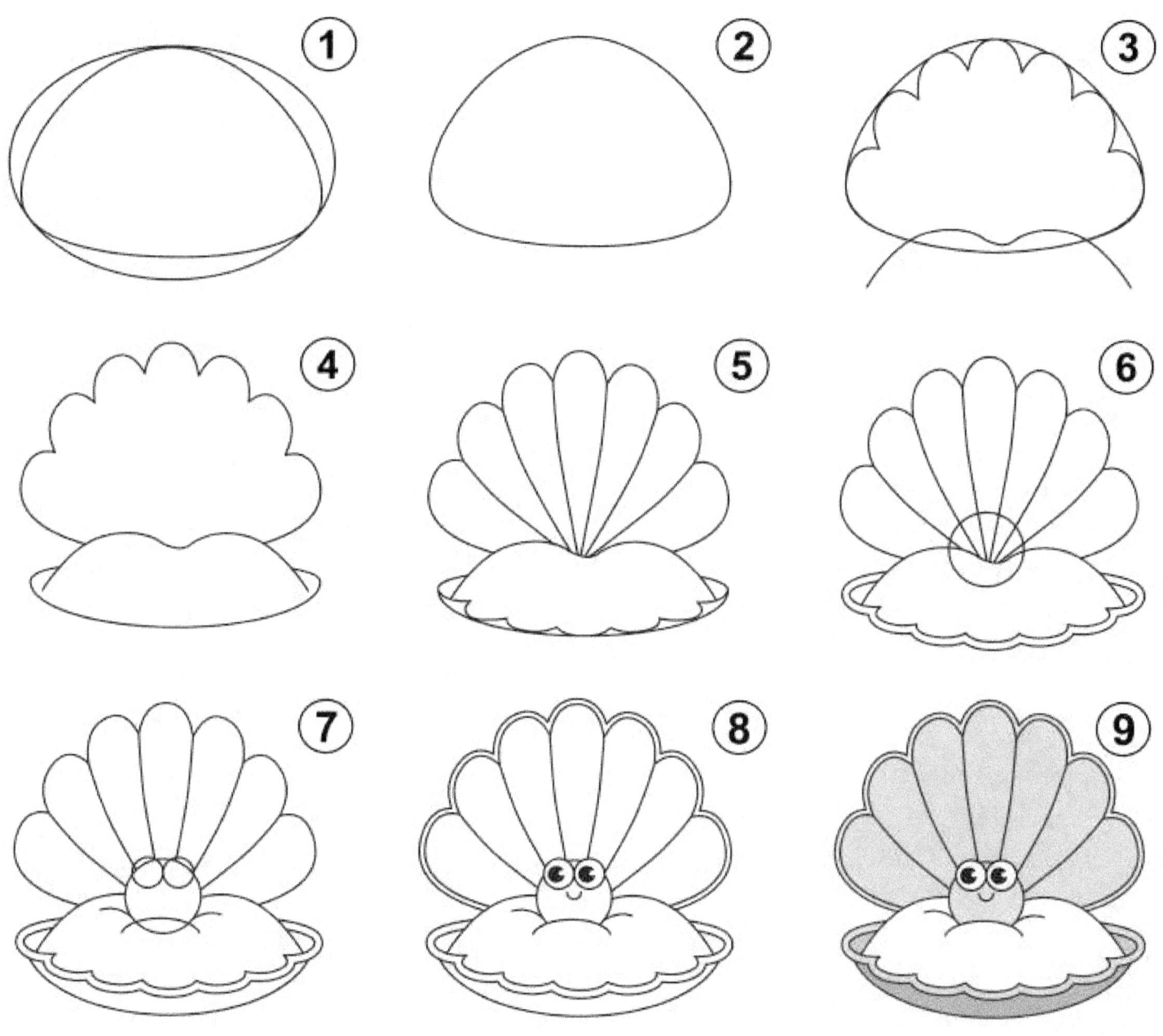

Step by step drawing tutorial

BLANK PRACTICE PAGE

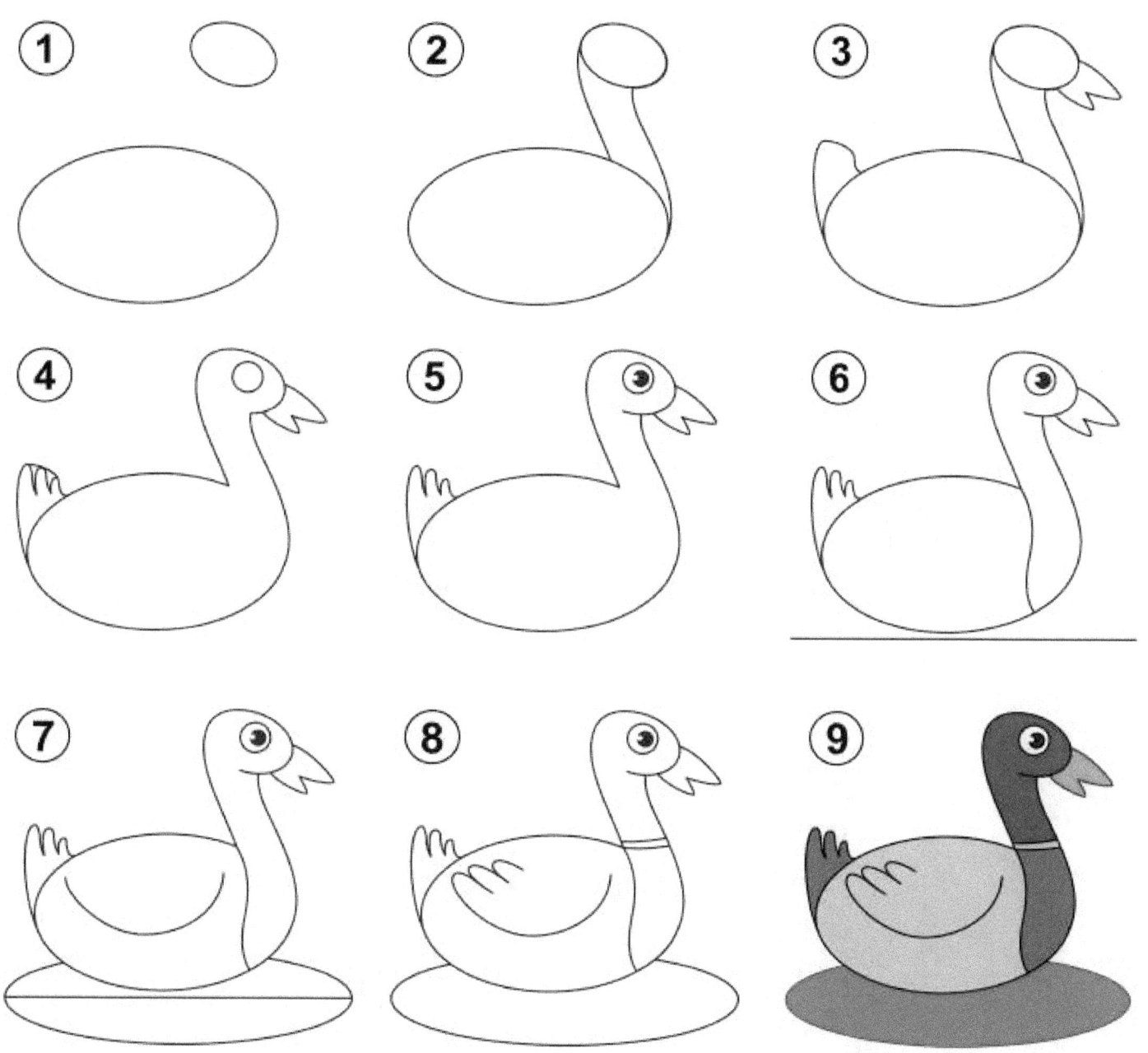

Step by step drawing tutorial

BLANK PRACTICE PAGE

Step By Step Drawing Sheep

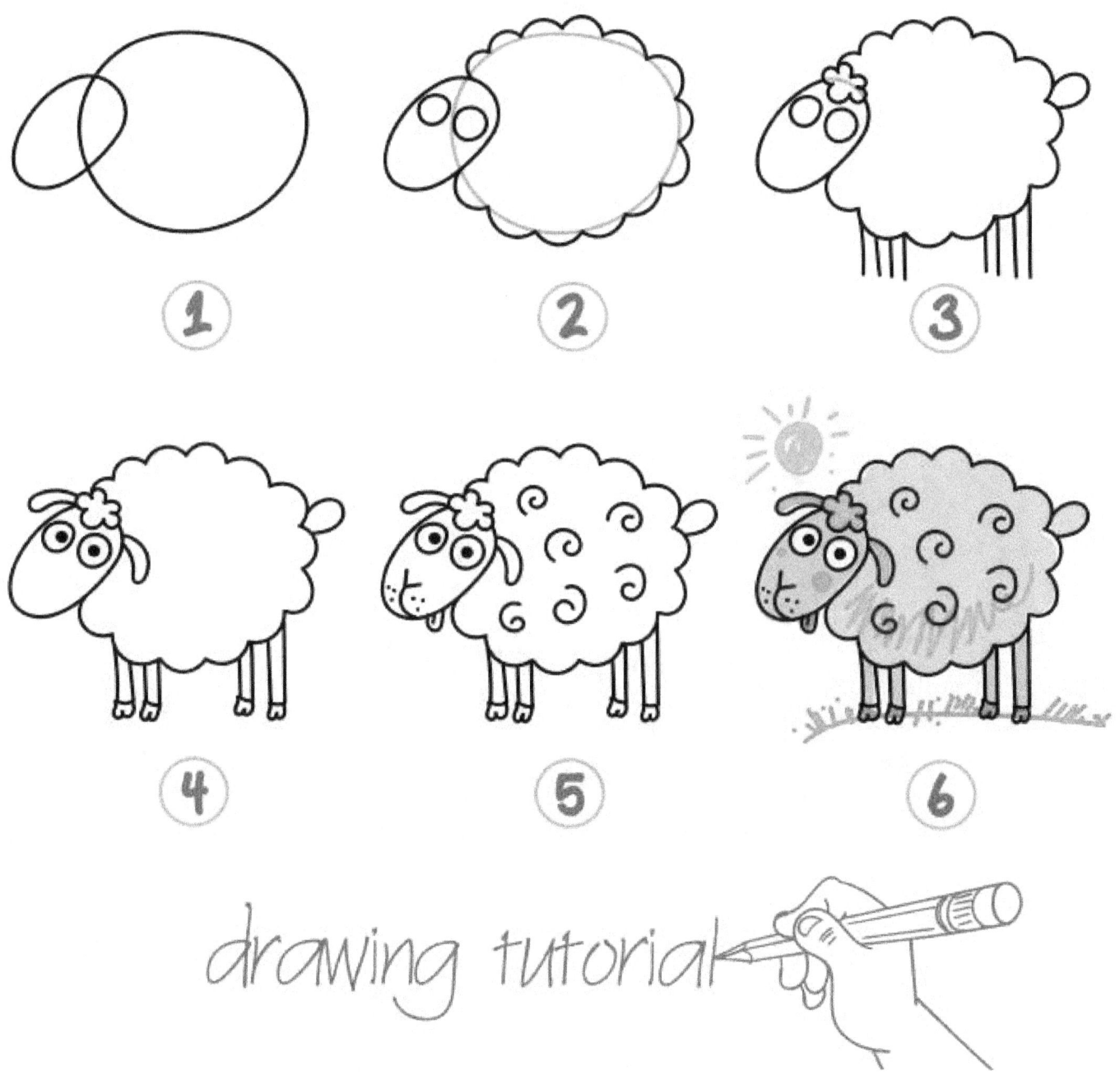

drawing tutorial